The Miniature Portrait Collection
of The Carolina Art Association

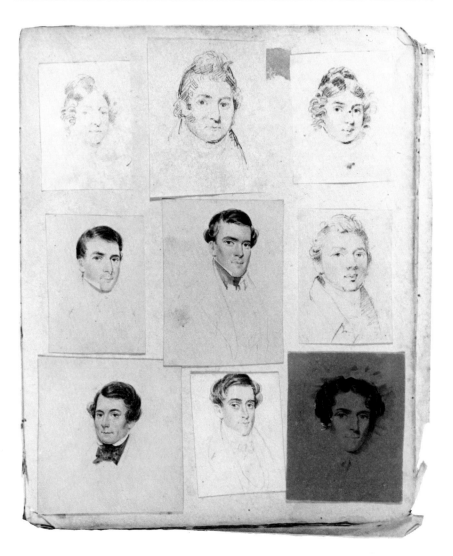

A page from Joseph Jackson's scrapbook

❧ *The* ❧
Miniature Portrait Collection
OF THE CAROLINA ART ASSOCIATION

By Martha R. Severens

Edited by Charles L. Wyrick, Jr.

Carolina Art Association

GIBBES ART GALLERY • CHARLESTON, SOUTH CAROLINA

Copyright ©1984 by Carolina Art Association,
135 Meeting Street, Charleston, South Carolina
All rights reserved.
Printed in the United States of America.
This book, or parts thereof, may not be reproduced
in any form without permission of the publisher.

Library of Congress Cataloging in Publication Data
Carolina Art Association
The miniature portrait collection of the Carolina Art Association.

Bibliography: p.
Includes index.
1. Portrait miniatures, American—South
Carolina—Charleston—Catalogs. 2. Portrait
miniatures—South Carolina—Charleston—Catalogs.
3. Charleston (S.C.)—Biography. 4. Carolina Art
Association. I. Severens, Martha R., 1945–
II. Gibbes Art Gallery. III. Title.
ND1311.9.C47C3 1984 757′.7′097579150740157915
84-11413
ISBN 910326-19-3

Cover Illustration: Henry Inman, *Thomas Fenwick Drayton*

This book was made possible, in part,
by a grant from the
NATIONAL ENDOWMENT FOR THE ARTS,
a Federal Agency.

ℒ Contents ℚ

Preface

The collection of the Carolina Art Association is varied, but its strength and depth lie principally in the area of American portraiture. Within this generic context, the miniature portraits form a distinctive and impressive group, numbering in the hundreds and ranging from sophisticated, European-influenced examples to naive, local efforts.

Although many of these miniatures have been featured in exhibitions here and at other museums and have been used to illustrate numerous articles and books, this publication marks the first time that the collection has been fully documented and published in its entirety.

This catalog and the art works represented herein result from the generous patronage, diligent study and sustained interest of a host of donors, scholars, staff members, funding agencies and friends. We have attempted to list as many of these as possible in the accompanying acknowledgments page.

It becomes my pleasure to acknowledge the most significant effort behind this publication—that of our Curator of Collections, Martha R. Severens. While juggling a host of other museum duties, she somehow managed to do original research on the collection, recheck earlier research, oversee the careful examination of each work, compile and edit the catalog entries, and see the manuscript through the publishing process. For this Herculean labor, she deserves our lasting gratitude.

It is our pleasure to add this volume to the list of Carolina Art Association publications and to invite you to heighten the pleasure of your perusal by visiting the Gibbes Art Gallery and viewing these wonderful portrait miniatures. Your efforts, as well as ours, will be rewarded.

CHARLES L. WYRICK, JR.
Director

✑ Acknowledgments ✑

The catalog of the Carolina Art Association's miniature collection would not have been possible without the support and assistance of many individuals. In particular, the substantial work on the collection initiated by Anna Wells Rutledge, historian of Charleston art, and the late Helen Gardner McCormack, whose emphasis was the sitters' biographies, made possible many of the attributions and identifications. In addition, the expertise of several miniature portrait scholars, including Sara Coffin of Sotheby Parke-Bernet and E. Grosvenor Paine, but more especially Robin Bolton-Smith, Associate Curator, National Museum of American Art, has been invaluable. Two conservators, Katherine Eirk, National Museum of American Art, and Carol Aiken, Baltimore, who undertook treatment of the collection during spring 1984 with a grant from the National Endowment for the Arts, have offered useful suggestions about the technical aspects of the miniatures and their care.

Numerous libraries have made available their extensive resources, in particular, the Charleston Library Society; the South Carolina Historical Society; the College of Charleston Archives and Library; the Library of the National Portrait Gallery / National Museum of American Art; and the New York Public Library.

But it is the staff of the Gibbes Art Gallery, both past and present, who have lent unwavering support for this project, and deserve the author's fullest appreciation: the late William C. Coleman, who wrote the initial National Endowment for the Arts grant application, Jean Stewart, Jack Rutland, Mary Muller, Angela Mack, Roberta Kefalos, Paul Figueroa, Dorothy Holton, Catherine Johnson, Jessie Johnson, Kenneth Tolbert, Sandy Hennessee, Rosalyn Morrison, Donna Sparkman London and many others. To Charles L. Wyrick, Jr., Director, a special thanks is due for his supervision of the manuscript and design. The photographers, Terry

Richardson and Linda and Tom Starland should be acknowledged for their professionalism and patience. Sandra Strother Hudson and Kathi L. Dailey of Athens, Georgia oversaw the myriad details of design and production with great care and common sense.

Finally, financial assistance from the Women's Council of the Carolina Art Association, the late Mrs. George H. Whipple and a grant from the National Endowment for the Arts, a federal agency, have brought this project to fruition.

<div style="text-align: center;">

MARTHA R. SEVERENS
Curator of Collections

</div>

Introduction

Miniature portraiture had its origin in Renaissance humanism.[1] When fifteenth- and sixteenth-century patrons and artists began to abandon religious themes, they turned to landscape, genre, and portraiture. Of these, portraiture was emphatically man-centered, with the primary concern being the creation of a credible likeness. Portraits of individuals in tempera, fresco, oil, marble, and terracotta proliferated, and a new stylistic vocabulary began to emerge.

While it is hard to pinpoint the exact beginning of miniature portraiture, it was most thoroughly nurtured at the Elizabethan court. Closely tied to royal patronage, the first miniatures resembled manuscript illuminations in their saturated colors, pictorial backgrounds, and concern for details. Elizabethan-era miniatures often had inscriptions and were frequently contained in elaborately jewelled cases, thus reinforcing their connections to manuscripts. These early miniatures were painted on vellum or pieces of card, further aligning them with the manuscript tradition.

With the introduction of ivory as the chief support around 1700, transformations in technique and conception occurred. For some time ivory had been employed on small toilet or snuff boxes, and, in retrospect, the transfer to portraits seemed natural. On occasion, artists continued to portray sitters on the tops of boxes, as George Engleheart did in his portraits of Penelope Ogilvy Orde and Benjamin

1. For the most concise and available surveys of the development of miniature portraits, see Robin Bolton-Smith, "Fraser's Place in the Evolution of Miniature Portraits," *Charles Fraser of Charleston: Essays on the Man, His Art and His Times*, ed. Martha R. Severens and Charles L. Wyrick, Jr., Charleston, SC, 1983, 39–56 and John Murdoch, Jim Murrell, Patrick J. Noon and Roy Strong, *The English Miniature*, New Haven, CT, 1981.

Stead. Ivory allowed greater translucence and delicacy of color, and gradually watercolors took precedence over other media. Pigments were generally obtained in lump form (figure 1) and were ground by the artist into a fine powder, and then small quantities of water and gum arabic were added to form a liquid suitable for painting. Some artists, such as Richard Cosway, learned to maximize the white of the ivory, much as a watercolorist uses blank white paper to heighten the value of his composition.

In general, the English examples are the most luminous, with brilliant blues characterizing the miniatures by Engleheart (colorplate IV). Handling of the pigment was also spontaneous and painterly, suggesting parallels to the grand manner portraiture of Joshua Reynolds and Thomas Gainsborough. In contrast, French artists tended to be more strictly controlled, frequently allowing pencil details to remain visible. They also preferred opaque, and usually steely-gray or blue backgrounds, which almost deny the translucent quality of the ivory.

American miniaturists, as represented in this catalog, vary considerably in their use of ivory. Some, such as the unidentified artist who painted Mr. and Mrs. Samuel Prioleau, lightly washed the background, a technique occasionally employed by Henry Benbridge. Other artists, including some who were trained abroad, like John Ramage, preferred a darker and deeper palette.

By the time of James Peale and Edward Greene Malbone a pleasing balance between the ivory and the pigment was achieved, with both artists using the natural color of the ivory to enhance flesh tones. In addition, Peale and Malbone—and later Charles Fraser—worked out careful systems of cross-hatching for the background. Gradually Fraser's technique evolved into more of a dotted or stippled approach, which in the late portraits became almost oppressively regular and insistent.

In some cases, artists like Joseph Jackson experimented with added quantities of gum arabic, which led to dark hues, a leathery quality to the paint surface, and, subsequently, to flaking. The mid-nineteenth-century preference for somber tones, as reflected in women's dress styles, and a tendency to imitate oil portraits, directed the artists toward heavier and darker pigmentation. Miniaturists may also have been responding to the invention of daguerreotypes, which permitted accurate, speedy and inexpensive likenesses. Competition between the two media was stiff, as witnessed by announcements in the local papers, which cited daguerreotypes as "photographs bordering on the Miniature Paintings," or called daguer-

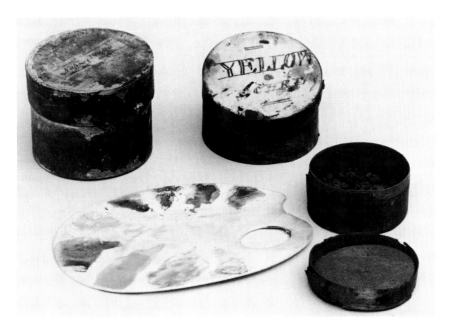

Figure 1. Charles Fraser's Pigments and Leila Waring's ivory palette

reotypes "of superior beauty and excellence, having a brilliant white tone; and when required will be colored up to nature surpassing the beautiful style of Miniature Painting."[2] Perhaps in emulation of this new method, miniatures became excessively clear in light, precise in detailing, and the sitters were often portrayed in rigid frontal poses. By the beginning of the twentieth century, lighter colors pervaded, and artists used more intimate poses and settings and allowed the surface of the ivory to come through, apparently in response to Impressionism.

Throughout their evolution, miniatures were created as expressions of affection, not as monumental, public depictions. Frequently shared by a young couple (Thomas Pinckney and Eliza Izard, Sarah Catchett and Thomas Robson) they were painted under romantic circumstances and occasionally bore hopeful inscriptions, such as that on Robson's locket (figure 4): "To bosom of Sarah be this image confin'd / An emblem of love and esteem / Bestow'd by a friend desirous to find / A place in that bosom unseen." Mothers clearly wanted portrayals of their children: Mrs. Gaillard, for example, had her sons' portraits mounted on a swivel in a brooch; Mrs. Campbell's three children were painted by Fraser in 1845. Offspring as well desired portraits of their parents and ancestors, which led in many instances to likenesses of older citizens such as those of the various Mrs. Prioleaus, Catherine Cordes, Plowden Weston, and Nathaniel Russell.

Miniatures at times served to document other works of art—either original miniatures, pastels or oil paintings. For instance, Fraser is known to have copied works by the Colonial artists Henrietta Johnston and Jeremiah Theus, as well as making versions of his own ivories. This multiplication can be explained by a desire on the part of patrons to have their own copies of venerated images.

The working methods of miniaturists can be inferred from a variety of sources, including portraits of them at work, instructional manuals, letters from artists and sitters, and inventories and account books. Charles Willson Peale, in his 1789 portrait of his brother James, shows the artist at work at a portable desk which has drawers for the storage of ivories and pigments (figure 2). Near at hand is a glass of water for mixing the pigments. Peale's brush is a very fine one. Other artists, like Anson Dickinson and Edward Greene Malbone, kept their pigments in containers made of ivory. The ivory probably came from Africa via England, and was specially

2. *Courier*, 30 March, 1847 and 25 January, 1848, as cited in Anna Wells Rutledge, *Artists in the Life of Charleston: Through Colony and State from Restoration to Reconstruction*, Philadelphia, PA, 1949, 164.

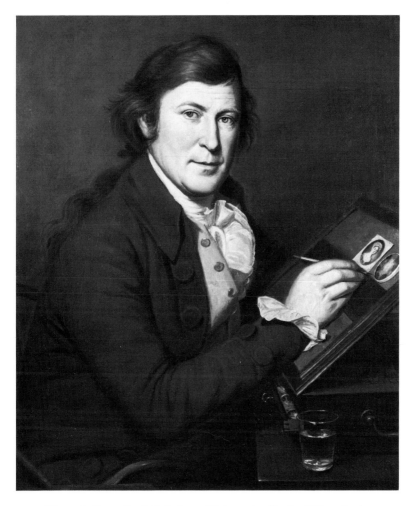

Figure 2. *James Peale Painting a Miniature* by Charles Willson Peale
(Collection of Mead Art Museum, Amherst College)

cut along the grain. Malbone's inventory following his death records $167.40 worth of ivory consisting of numerous portrait-size pieces arranged on eighteen sheets of paper.[3]

In his account book, on the last page, Fraser drew his self-portrait and included a list of pigments, evidently the ones he himself employed (figure 3): vermilion, carmine, burnt siena, Indian yellow, indigo, royal smalt, verditter, Indian red, ivory black, French white.[4] Several small canisters of his pigments, red, yellow, and blue, have made their way into the CAA collection (figure 1). For mixing her pigments Leila Waring used a small sheet of ivory for her palette.

For lockets and frames, artists sometimes made their own, as John Ramage is known to have done.[5] Trained as a goldsmith, he developed a distinctive case design with a chased back and fluted and chased edges. Others seemed to have recommended certain jewelers for specially designed lockets. In many instances elaborate hair devices were invented for the versos, often in combination with small seed pearls, enamel, and gold initials (figure 4). The preciousness of the materials enhanced the intimacy and delicacy of the portraits themselves. At times a notable discrepancy exists between the portraits of men and of women: the frames of the wives' portraits are simple, while their husbands are beautifully presented. This is the situation with the portraits of Mr. and Mrs. James Gibbes. The difference in the Gibbes' frames has been explained by the fact that *she* would have worn his likeness, while *he* might have carried her portrait in a vest pocket (colorplate XVI).

In the antebellum period, small rectangular leatherette cases replaced the smaller lockets. These were designed to be displayed, perhaps on a desk or a toilet table, and they offered more protection for the delicate ivory. Under the metallic mats one frequently finds an inscription or watercolor sketches where the artist was trying out his pigments (figure 5).

Since the tools and materials involved were small, the miniaturist could easily transport them to a location convenient to the sitter. Many of the artists working in Charleston maintained rooms near the commercial center of the city. Vallée, for

3. Ruel Pardee Tolman, *The Life and Works of Edward Greene Malbone, 1777–1807*, New York, NY, 1958, 67.

4. Fraser's account book is in the CAA collection, gift of J. Alwyn Ball, and is published in Severens and Wyrick, *Charles Fraser*, 120–146.

5. John Hill Morgan, *A Sketch of the Life of John Ramage, Miniature Painter*, New York, NY, 1930, 12.

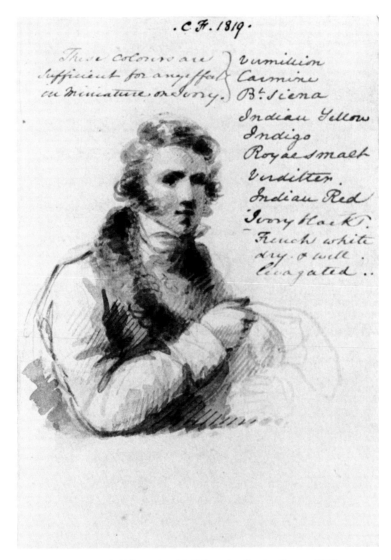

Figure 3. *Self-Portrait with Colours* by Charles Fraser, 1819,
from Charles Fraser's Account Book

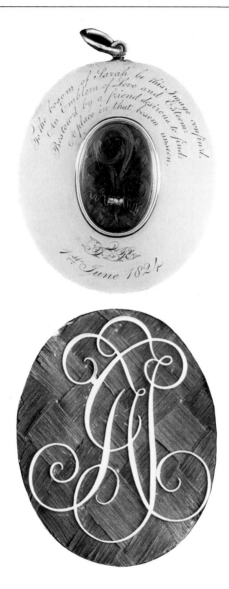

Figure 4. *Above:* Verso from Thomas Robson's locket showing inscription;
below: Verso showing hair device and initials from Auguste Paul Trouche's *Self-Portrait*.

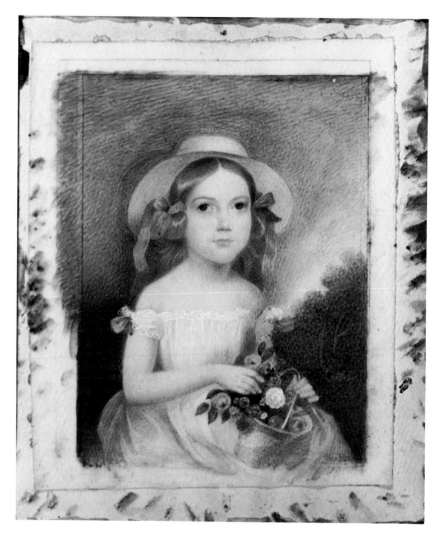

Figure 5. View of mount and sketches from miniature by Charles Fraser

instance, had quarters at 15 Queen Street and later at 118 Broad Street. Vallée advertised the convenience of his services in a newspaper announcement: "Ladies wishing to be attended at their houses, may depend on punctuality."[6] The artists' rooms were also used for exhibition of sample portraits, especially by artists who were visiting the city: "Edward Greene Malbone has lately arrived here, and intends to practice the above art during his stay in this place. Specimens of his work may be seen at his room at Mrs. Miott's boarding house at the corner of Queen and Meeting streets."[7]

That artists working in Charleston aimed to please is clear from statements in the press from artists. Pierre Henri even issued a kind of guarantee: "in order to deserve the confidence of those who chose to favor him with employment, he engages from this date, to take back any likeness not bearing a pleasing resemblance to the original." He also assured future patrons that only a short time was needed for the painting of the portrait: "he generally takes but three sittings of half an hour each, and seldom keeps anybody longer."[8]

For the periods Malbone was working in Charleston, it has been estimated that he painted about twelve miniatures a month, a very prodigious output.[9] Fraser, on the other hand maintained a more leisurely pace. In his account book he made small notations (figure 6), "mem; down to this time 10 Nov 1837 from the year 1818 I have painted in all 350 miniatures." Malbone's fees for 1800–1807 and Fraser's for 1818–1830 were comparable, that is, $50 for a standard portrait. About 1830, Fraser reduced his price to $40. What motivated this change is not clear, but it may be indicative of a decline in the market. In comparison, portraitists in oil, such as Thomas Sully, received between $75 and $100 for average-size paintings during this period.[10]

In order to supplement their income, miniaturists often followed other pursuits. Fraser practiced law for eleven years, and it has been interpreted that he did so in order to have a cushion to fall back on. "In that time he had secured a competency,

6. *Times*, 11 February, 1805.

7. *South Carolina Gazette and Daily Advertiser*, 17 February, 1801.

8. *City Gazette and Daily Advertiser*, 23 December, 1791.

9. Tolman, *Malbone*, 167.

10. Edward Biddle and Mantle Fielding, *The Life and Works of Thomas Sully*, Phildelphia, PA, 1921, passim.

Figure 6. Charles Fraser's Account Book, pages one and two, 1818–1839

he then abandoned the law, and devoted himself to the pursuit of the profession he loved most—painting."[11] Bounetheau was a bookkeeper by profession and, together with his wife, Julia Clarkson Dupre, he held "classes in drawing and oil painting . . . for the youth of both sexes."[12] In turn, Joseph Jackson and his wife sustained themselves by restoring old and damaged paintings.

While the Bounetheaus and Jacksons, as well as the Benbridges, exemplify couples who collaborated on painting and related activities, it is noteworthy that very few women artists working in Charleston can be clearly identified in an art form which was genteel in scale, technique and subject matter. However, the women miniaturists whose work is in the CAA collection are particularly interesting and represent distinct attitudes toward their art careers: Mary Roberts was a widow who attempted to continue her husband's trade in views of Charleston and supplemented it with her own skills in miniature portraiture; Louisa Strobel upon her marriage abandoned miniature painting; and Leila Waring, who never married, apparently gave up her career when she returned to Charleston to care for her ailing mother.

Attributions of miniatures are based on a variety of factors, including documentation and tradition, as well as signatures. A number of artists, including Malbone and Fraser, kept account books with lists of sitters' names and the dates the portraits were done. In some instances, provenance has sustained the identification of both artist and sitter, as the portraits were passed down through the generations. Signatures on the face of miniatures tend to be the exception rather than the norm, with initials dominating over full names. Henri (PH), Peale (IP), Engleheart (E), and sometimes Fraser (CF) preferred monograms, realizing perhaps that individual letters intruded less on the small scale portraits. Vallée and Clorivière (Picot) characteristically signed their names, the former choosing to do so in clear graphite (figure 7). The miniature of Eliza Izard shows Malbone's name scratched into the paint surface, a device rarely seen in his ivories (colorplate IX).

Inscriptions are often found on the verso of miniatures, as with Fraser, who not only signed his name but also gave date and place and the instruction: "Never remove this paper." Another means of identification occurs when artists included

11. John Belton O'Neall, *Biographical Sketches of the Bench and Bar of South Carolina*, Charleston, SC, 1859, II, 313.

12. Rutledge, *Artists in the Life of Charleston*, 160.

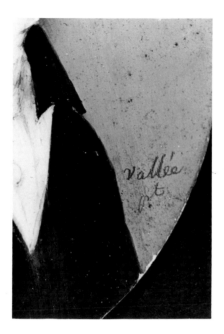

Figure 7. Signature: *Vallée* from John Christopher Shulz's miniature

their calling cards or newspaper advertisements in the lockets as backing papers, as Samuel Smith did in his portrait of John S. Cogdell.

Dates for miniatures can be ascertained from signatures, inscriptions on lockets or documentary evidence. In the catalog entries the date the miniature was painted, when known, immediately follows the measurements. On the basis of this information the portraits are arranged in chronological sequence whenever an artist painted more than one.

The development of the CAA collection closely parallels local and regional trends of the late 1920s and 1930s. At a time when Charlestonians began to take conscious steps to preserve the city's architectural heritage, the Gibbes Art Gallery sponsored three major exhibitions.[13] These exhibitions laid the foundation for the association's collection, and focused on the rich tradition of Charleston patronage of miniature painters. Coincidentally, on the national level, a new interest in American art and decorative arts began to emerge, resulting in several pivotal publications and exhibitions, including Harry Wehle and Theodore Bolton's *American Miniatures 1730–1850* and the Metropolitan Museum of Art's *Exhibition of Miniatures Painted in America 1720–1850*. Simultaneously, periodicals such as *Antiques* magazine and the *American Collector* carried articles on individual miniaturists, often providing checklists of known works.

In Charleston, a dynamic group of individuals including artists, scholars and patrons embraced this interest in miniatures. The watercolorist Alice Ravenel Huger Smith, together with her father, the historian D. E. H. Smith, wrote the seminal volume on Charleston's very own antebellum miniaturist, Charles Fraser. Their approach, however, remained historical-genealogical, rather than art historical. Alice Smith, with Leila Waring, a miniaturist in her own right, oversaw the details relating to the 1930s exhibitions.

Anna Wells Rutledge, who would later write the impressive volume *Artists in the Life of Charleston*, was the key researcher and detective among the group. Her laborious and careful searching through local newspapers has made it possible to document artists who came to Charleston before 1850. Major donors, such as Mr.

13. *A Short Sketch of Charles Fraser and a List of Miniatures and Other Works Exhibited by the Carolina Art Association*, Charleston, 1934; *Exhibition of Miniatures From Charleston and Its Vicinity Painted Before the Year 1860*, Charleston, 1935; *An Exhibition of Miniatures Owned in South Carolina and Miniatures of South Carolinians Owned Elsewhere Painted Before the Year 1860*, Charleston, 1936.

and Mrs. Victor Morawetz and Eliza Huger Dunkin Kammerer, themselves collectors, provided the necessary funds for the purchase of significant miniatures relating to Charleston and the original installation of the miniature collection. Their beneficence has inspired others to donate family heirlooms to the collection.

The miniatures complement the oil paintings in the CAA collection, and provide instructive comparisons in both technique and interpretation. James Shoolbred Gibbes, benefactor of the Gibbes Art Gallery, was portrayed about 1850 by George Flagg in an oil on canvas; in it he appears successful, somber and slim. In contrast, the enamel portrait of him of 1866 shows him with a fuller face and more flaccid expression (colorplate XVI). The CAA miniature collection, published here for the first time, makes a cohesive statement about the little-known art form, and offers numerous insights into Charleston's cultural heritage.

MARTHA R. SEVERENS

Abbreviations and Notes

CAA	Carolina Art Association
c.	circa (about, for dates)
cont.	continued
mm	millimeter
SCHM	South Carolina Historical Magazine
SCHS	South Carolina Historical Society

The catalog entries are arranged in alphabetical order by artist, followed by a section for attributed works and works by unidentified artists. For artists who did several miniatures the organization is chronological, based on documented and dated examples as well as stylistic evidence. The attributed section consists of former and traditional attributions and new attributions. Each is explained in the catalog entry. For women the name in use at the time of the portrait is used, as in Eliza Rutledge (Mrs. Henry Laurens) who was fifteen at the time of her portrait.

In all colorplates, with the exception of Plate II (*John Stock Bee* by Henry Bounetheau) the miniatures are shown according to their actual size. Black and white illustrations are reproduced in three standardized sizes, which reflect as closely as possible the sizes of the miniatures.

The date of the miniature, when known, is given immediately following the measurements. Measurements are given in millimeters, and height precedes width. Each miniature is identified by its accession number, which records the year in which the acquisition was made. For instance, 36.2.1 indicates that the work was acquired in 1936.

The
Miniature Portrait Collection

Documented Works

J. B. Alexander

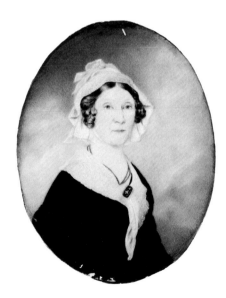

MRS. PETER SMITH
(SARAH POGSON)

Watercolor on ivory, 85 × 70 mm
Gift of Sophia Cadwalader in memory
of Eliza Middleton Fisher
41.3.1

A native of Essex, England, Mrs.
Smith emigrated to Charleston in
1793. Her husband was Judge Peter
Smith. Her tombstone in St. Philip's
Churchyard states, "The Christian
Faith, Hope and Charity she strove
through life to exemplify."

No information is available on Alexander, except that he was painting
miniatures in Charleston in 1839. His
style is characterized by crisp delineation of details, erect poses and light
backgrounds which create a halo-effect. Mrs. Smith's portrait is unusual
because of its bright pink hues.

Henry Benbridge
1743–1812

Benbridge, a native of Philadelphia, was an accomplished portraitist in oil on canvas, as well as a successful miniaturist. His early portraits reveal the influence of the English painter John Wollaston. In Rome 1765–1769, the young Benbridge studied old masters, learned glazing techniques and was exposed to the High Baroque style of Anton Mengs and Pompeo Batoni. Apparently, he never devoted much attention to drawing or the study of anatomy. After spending half of 1770 in London, where he was associated with Benjamin West, Benbridge returned to Philadelphia and remained there two years.[1]

About 1772 Benbridge moved to Charleston, followed in 1773 by his wife Hetty Sage (Esther), herself "a very ingenious Miniature Paintress."[2] Hetty Benbridge received some training from Charles Willson Peale, and a small group of miniature portraits, mostly of women, have been attributed to her.[3]

Considered a sympathizer of the colonists, Benbridge was held prisoner by the British at St. Augustine 1780–1782. After two years in Philadelphia, he settled once again in Charleston until the late 1790s when he appears to have moved to Norfolk, then Baltimore, to live with his son. He painted little in later life, apparently suffering from asthma.

Benbridge's miniature style is distinctive. Preferring small format ivories that were usually encased in lockets, he painted his sitters in a ruggedly individualistic manner. Usually only the heads are shown, and are placed toward the top of the ivory. Features are strongly modelled with sharp contrasting light, and blemishes and wrinkles are rarely disguised. Many portraits of men reveal "five o'clock shadows." Although Fraser probably never met Benbridge, he correctly evaluated Benbridge's contribution:

> Bembridge [sic] painted a good deal in Charleston; he had had great advantages, having studied in Rome under Mengs and Pompeo Battoni It is certain that the portraits by Bembridge were sought after eagerly on his return and he was held in high estimation by his contemporaries I cannot say I admire his portraits. They bear evident marks of a skilful hand, but want that taste which gives to a portrait one of its greatest charms. His shadows were dark and opaque, and more suitable to the historical style.[4]

1. Robert G. Stewart, *Henry Benbridge 1743–1812: American Portrait Painter*, Washington, 1971.

2. *South Carolina Gazette*, 5 April, 1773.

3. Stewart, *Benbridge*; Anna Wells Rutledge, "Henry Benbridge (1743–1812?), American Portrait Painter," *American Collector*, xvi, 9 (Oct 1948), 8–10 and xvi, 10 (Nov 1948), 9–11, 23.

4. William Dunlap, *A History of the Rise and Progress of the Arts of Design*, Boston, 1981, 1, 142.

Probably painted in the mid-1770s, the ivory is still mounted to a paper on which the artist seems to have sketched. The sitter, as in so many of Benbridge's portraits, is placed very close to the upper edge of the ivory and totally dominates the small oval.

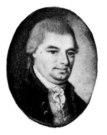

JOHN HUGER, 1744–1804
Watercolor on ivory, 41 × 32 mm
Gift of Mrs. Percy Kammerer
62.33.1

At age ten Huger inherited extensive acreage in Craven County from his father, and six years later was commissioned an Ensign in the Regiment of Foot during the Cherokee War. Throughout his adult life he served city and country, and was active in the Revolution. He participated in the First and Second Provincial Congresses, the Council of Safety and in the State Convention for the Federal

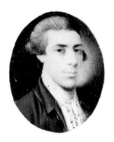

DR. ROBERT PRINGLE,
1755–1811
Watercolor on ivory, 32 × 25 mm
Gift of Victor Morawetz
36.7.6

Pringle studied medicine in Edinburgh and practiced as a physician in Charleston 1778–1783. He was active in the importing business for a few years, and then planted cotton and rice in Colleton County. In 1792 he was commissioned a surgeon of the Colleton County Regiment. He was the father of James Reid Pringle.

Constitution. He was the first Secretary of State in 1776 for South Carolina and second Intendant (Mayor) of the City of Charleston 1792–1794.

Benbride has clearly depicted all of Huger's features, including his double chin, cleft chin and mole. The modelling is almost sculptural and is enhanced by the lightened area behind the sitter's head. The miniature was probably painted in the mid- to late 1770s.

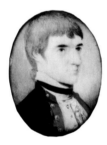

BARNARD ELLIOTT, 1740–1778
Watercolor on ivory, 30 × 25 mm
Gift of James Lowndes
10.1.1

Elliott is shown wearing the uniform of the Fourth South Carolina Regiment of the Continental Line. Before his death he attained the rank of Lieutenant Colonel. Elliott read the Declaration of Independence to the citizens of Charleston in August, 1776.

Miniatures of patriots such as Elliott probably caused the British to associate Benbridge with the Revolutionary cause. Actually, he also painted portraits of loyalists. Painted before 1778, it is typical of Benbridge's realism. Its light coloring, while atypical, may be a result of fading.

WILLIAM GIBBES, 1722–1789
Watercolor on ivory, 35 × 30 mm
Gift of Harriet C. Wilson
68.23

Colorplate I

Gibbes, who owned extensive property in the parishes of Christ Church, St. George's and St. John's, Colleton, was a shipowner and merchant. In the City of Charleston he, together with three others, filled in land at the tip of the peninsula where he built a large, distinguished home in the Georgian style. Gibbes served in the Commons House of Assembly in 1772 and 1774 and in the two Provincial Congresses. He was appointed a Justice of the Peace in 1776.

Benbridge has accented the serious demeanor of the sitter by heavy shadows on the face and deep-set eyes. The wine-red of the jacket adds a strong note to the likeness as well.

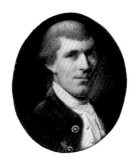

I.
Henry Benbridge
William Gibbes

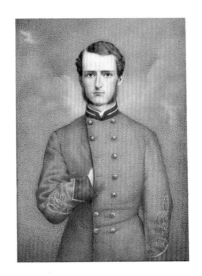

II.

Henry Bounetheau

John Stock Bee

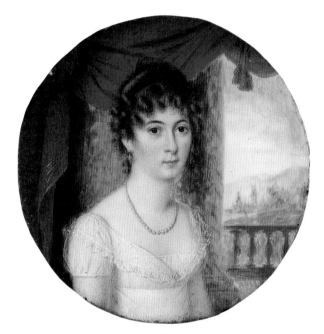

III.
Louis Antoine Collas
Mrs. John Ashe Alston

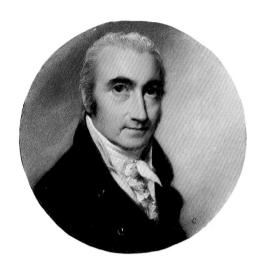

IV.
George Engleheart
Benjamin Stead, Jr.

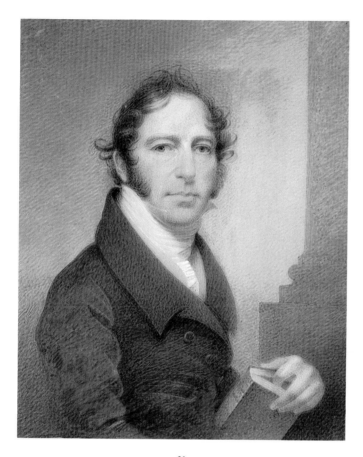

V.
Charles Fraser
Self-Portrait

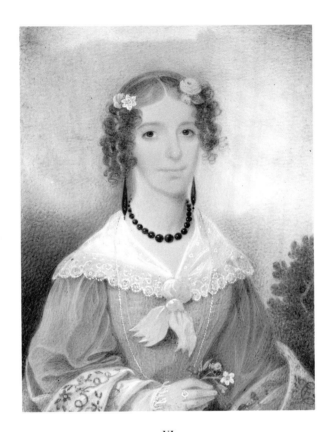

VI.

Charles Fraser

Mary Theodora Ford

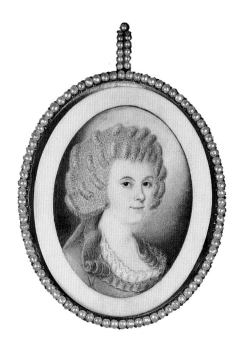

VII.
Pierre Henri
Mrs. John Faucheraud Grimké

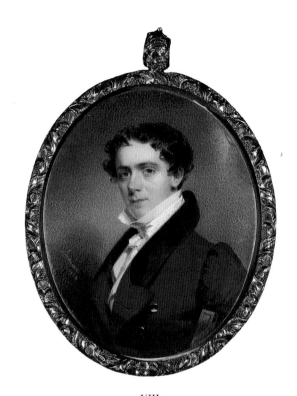

VIII.
Henry Inman
Thomas Fenwick Drayton

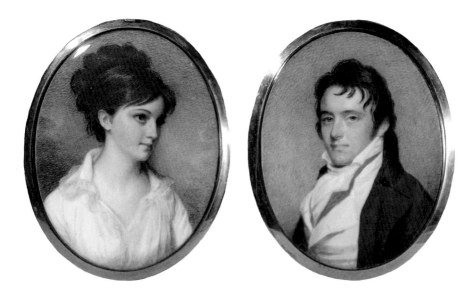

IX.

Edward Greene Malbone

Colonel and Mrs. Thomas Pinckney, Jr.

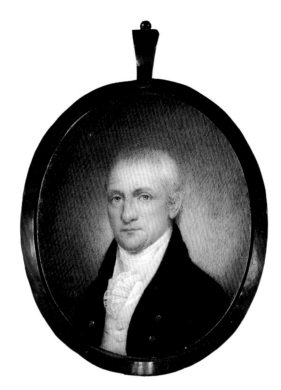

X.
James Peale
Jared Bunce

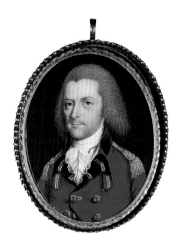

XI.
John Ramage
Benjamin Faneuil Bethune

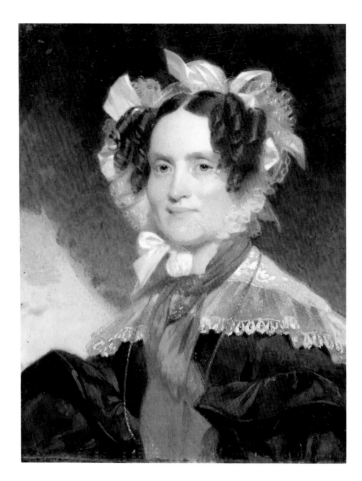

XII.
Andrew Robertson
Mrs. Arthur Middleton

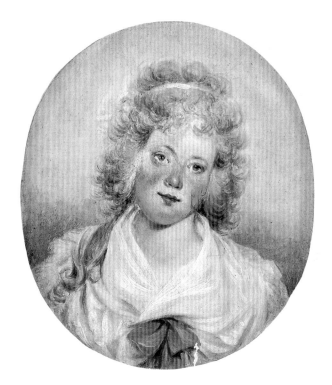

XIII.
John Trumbull
Eliza Rutledge

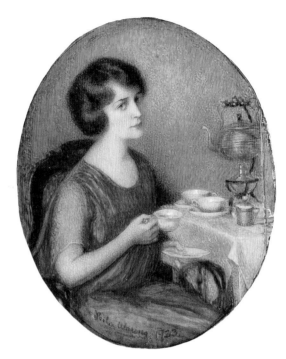

XIV.
Leila Waring
"Afternoon Tea," (Dorothy Waring)

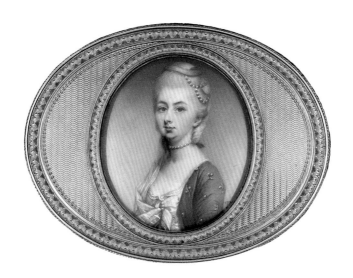

XV.
Attributed to Henry Spicer
Mrs. Ralph Izard

 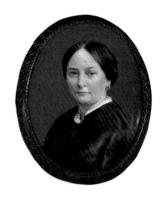

XVI.
Unidentified artist
Mr. and Mrs. James Shoolbred Gibbes

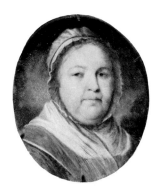

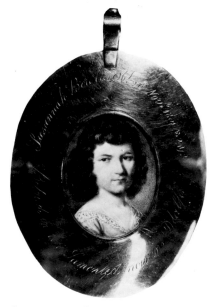

MRS. MUMFORD MILNER
(ELIZABETH BREWTON),
1724–1786
Watercolor on ivory, 45 × 40 mm
Gift of Mrs. B. S. Nelson
67.34.2

The daughter of Robert Brewton, a
prominent Charleston banker, at the
time of her death Elizabeth Milner
was a wealthy woman in her own
right.

Slightly larger than the other mini-
atures, Mrs. Milner's portrait is impos-
ing; Benbridge has not avoided the
fact that Mrs. Milner was plump and
matronly. The miniature was painted
before 1786, the year of her death.

SUSANNAH DRAYTON
(MRS. TOBIAS BOWLES),
1777–1801
Watercolor on ivory, 35 × 27 mm
Gift of Dorothy Waring
80.5.2

The daughter of John Drayton and Re-
becca Perry, Susannah was painted in
1787; at the same time Benbridge
painted her sister and her mother. The
ivory is presently contained in a
double locket with a larger portrait of
her attributed to Henri, which bears
the following inscription: "Susannah
Bowles obt 29th Novr 1801 ae 24 ys/
Beloved in life, lamented now in
death."

As in the portraits of male sitters, Benbridge here has used sharp lighting which strongly models the face. The end result is considerably less feminine than the later portrait by Henri.

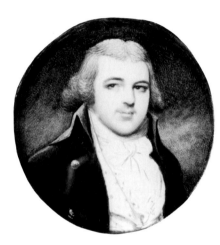

TOBIAS BOWLES, 1771–1808
Watercolor on ivory, 44 mm diameter
Gift of Dorothy Waring
80.5.3

Born in the Bahamas, Bowles married Susannah Drayton in 1795.

The round shape of this locket and the inclusion on the verso in brown tonalities of a scene with a young woman is unusual for Benbridge, and has led some to attribute this miniature to other artists, including Charles Willson Peale, Hetty Benbridge, and an unnamed British artist.[1] However, the individualistic treatment and strong coloring are entirely in character with Benbridge's work, and do not relate to the more delicately painted compositions of Hetty Benbridge.

1. The Peale attribution was given in the 1935 exhibition; Anna Wells Rutledge in the *American Collector* suggested Hetty Benbridge; and E. P. Richardson in his review of Stewart offers the British artist in *Pennsylvania Magazine of History and Biography*, Philadelphia, October 1971, 50.

Henry Bounetheau
1797–1877

Born in Charleston into a family of Huguenot ancestry, Bounetheau (also spelled Bonnetheau), became a competent practitioner in miniature portraiture while pursuing a career as a bookkeeper. Nothing has come to light about his education, but he seems to have learned much from the miniatures of Fraser, which he frequently copied. By 1819 his reputation as an artist had already been established. He was an acknowledged musician as well and a member of a group recorded by Thomas Middleton as *Friends and Amateurs in Musick*, 1827.[1] In 1841 he married Julia Dupre, herself an accomplished artist in

oil and pastel who had studied in Paris and whose mother ran a private school. Together in the mid-1850s, Mr. and Mrs. Bounetheau conducted a drawing school. Although quite an old man at the time of the Civil War, he was a private in the reserves, but spent most of the war years in Aiken, SC.

As an accountant, Bounetheau was associated with the firms of Dart and Spear, James Hamilton & Son, Co. and C.N. Hubert & Co. He also held a position for a time at the Bank of Charleston. Perhaps because of this career he did not consider himself fully professional, and he is known to have advertised only once in the local newspapers. He was awarded a prize in the 1849 exhibition of the South Carolina Institute.

Bounetheau's known miniatures range over four decades. His style is deeply indebted to Fraser's and several of Bounetheau's works have been mistakenly attributed to Fraser. And, like Fraser, a clear decline in quality occurs in the later examples. In addition, Bounetheau was a known copyist—not only after Fraser, but also after daguerreotypes and oil portraits (such as Gilbert Stuart's famous painting of George Washington) and engravings.

The following description can be found in his obituary: "The life of Mr. Bounetheau was unusually uneventful, and yet he made an impression wherever he went, by the serenity and amiability of his character."[2]

1. Shecut, J.L.E.W., *Medical and Philosophical Essays*, Charleston, 1819, 54; drawing in CAA collection.

2. *Courier*, 1 February, 1877.

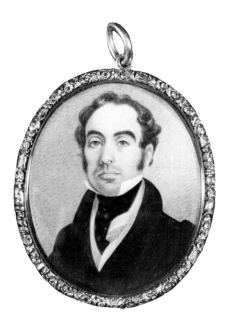

THOMAS ROBSON, 1797–1833
Watercolor on ivory, 60 × 55 mm, 1824
Signed at left: Bounetheau
Bequest of John W. Robson
55.9

Robson, who was born in Northumberland, emigrated to South Carolina, settling first in Columbia where he ran a grocery business. Later he was active in a shipping firm.

One of Bounetheau's more convincing portraits, Robson's miniature shows a serious young man in crisp, realistic terms. Somewhat in contrast to this businesslike image is the provocative inscription on the reverse of the locket: "To bosom of Sarah be this image confin'd/An emblem of love and esteem/bestow'd by a friend desirous to find/A place in that bosom unseen. T.R. 1st of June, 1824." The locket evidently was dedicated to Sarah Ann Catchett, who became Mrs. Robson in 1824.

WILLIAM RAVENEL, 1806–1888
Watercolor on ivory, 92 × 70 mm
Gift of Victor Morawetz
38.20.2

Ravenel was a partner in the firm of Ravenel Bros & Co., which conducted business in cotton as well as in ships.

It is interesting to compare the likeness of Ravenel to portraits of young men by Malbone and by Fraser during the 1820s. Whereas Malbone and

Fraser tended to emphasize the handsome features of their sitters and endowed them with a sense of vitality, Bounetheau's approach is more somber. This may reflect a change in taste and may also be explained by the conservative nature of Bounetheau's sitters who frequently were merchants and businessmen.

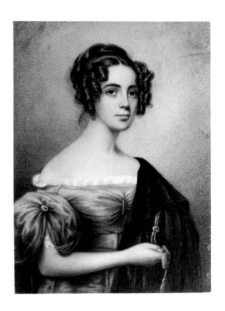

MRS. JOSEPH ALLEN SMITH IZARD (EMMA MIDDLETON HUGER)
Watercolor on ivory, 109 × 81 mm, 1835
Signed, lower right: Bounetheau; on verso: Painted by Bounetheau

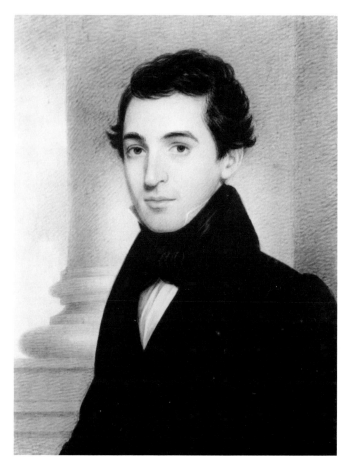

Henry Bounetheau
William Ravenel

Charleston So Ca Decm 1835
Gift of Fannie Marie and Rawlins
Lowndes Cottenet
51.6.1

Mrs. Izard was a great supporter of
the artist, and in a letter described
the circumstances of her portrait:

> I sat for my portrait soon after arriving
> from Goodwill, but the artist is so dis-
> satisfied with the picture, that he now
> implores me not to shew it and to per-
> mit him to take another He la-
> boured under great disadvantage in
> taking it, primo, I was the first lady
> whom he had taken, secondo, he had
> not touched the brush for months,
> terzo, he was little acquainted with my
> countenance, but he means the next to
> be "perfect". . . . He is self taught and
> quite deserving . . . and I trust he may
> be able to remain here where Heaven
> knows we have too little Genius, in any
> line—Mr. Fraser's miniatures do not
> compare with his painting at present.[1]

In its intensity, firm line and greenish
coloring, Mrs. Izard's miniature does
not resemble Fraser's at all, and thus
she should have been very pleased
with it.

1. Emma Huger to Adele Allston, 18 January,
1836, R.F.W. Allston Collection, SCHS, as
quoted in Rutledge, *Artists*, 160.

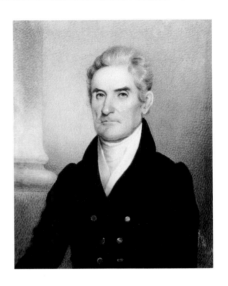

NATHANIEL HEYWARD,
1766–1851
Watercolor on ivory, 107 × 88 mm,
1837
Signed, below mat: copied by H.B.
Bounetheau in July 1837 from a
picture by Chs Fraser Charleston, SC.
Bequest of Julius Heyward
24.4.6

As a young boy Heyward participated
in the siege of Charleston by the Brit-
ish in 1780. He later emerged as an
extensive slaveholder (about 2500)
and at the time of his death he owned
seventeen plantations, most dealing in
rice along the Combahee River.

Fraser's original dates to 1829, and Bounetheau's copy is faithful to the original in details as well as handling. The blues, grays and greens are exceptionally fine.

A similar oil portrait by Thomas Wightman exists, and the miniature may be a copy of it. As in Emma Izard's portrait, there is a careful attention to details and textures, however, here the face has a youthful freshness.

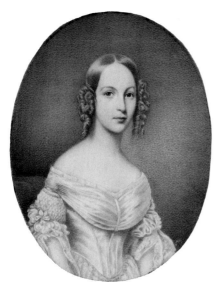

MRS. T. GRANGE SIMONS
(MARY ANN BENTHAM),
1820–1851
Watercolor on ivory, 120 × 95 mm
Bequest of Mrs. George Whipple
79.30.1

Mary Ann Bentham married Simons in 1840, and the miniature shows her in her wedding dress.

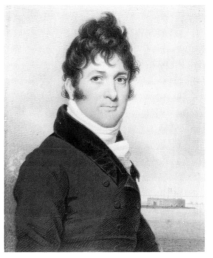

JAMES REID PRINGLE,
1782–1840
Watercolor on ivory, 115 × 94 mm, 1846
Signed below: H B Bounetheau after Fraser; on verso: painted by H B Bounetheau 1846 from a miniature by Chs Fraser 1820 Charleston SC
Gift of Victor Morawetz
36.7.12

(For a biography see Fraser: Pringle.)

This is an enlarged copy of Fraser's 1820 portrait, now in the CAA collection. While quite accurate in details, the handling is less spontaneous and fresh than Fraser's original.

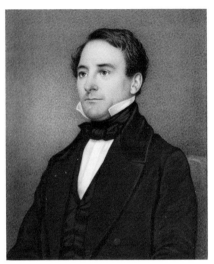

JAMES REID PRINGLE, JR.,
1813–1884
Watercolor on ivory, 107 × 83 mm
Gift of Alice R. H. Smith
36.12.1

The son of James Reid Pringle, he served as treasurer of St. Michael's Church and was active in the return of the church's bells from England.

One of Bounetheau's most successful miniatures, it combines a sensitive study of the sitter with a carefully balanced technique. The placement of the sitter is imposing.

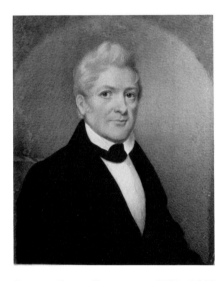

JAMES REID PRINGLE, 1782–1840
Watercolor on ivory, 114 × 97 mm,
1848
Signed on verso: HB Bounetheau,
pinxit 1848
Gift of Alice R. H. Smith
36.12.4

(For a biography see Fraser: Pringle.)

A faithful copy of a Fraser, where the stippling has become somewhat dry.

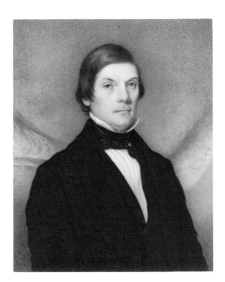

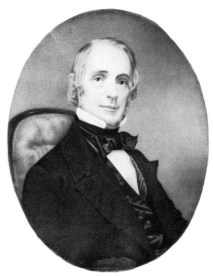

SEAMAN OR CHARLES
DUNDAS DEAS
Watercolor on ivory, 115 × 96 mm
Gift of Colonel Alston Deas
76.25.2

One of the nineteenth-century mem-
bers of the Deas family, the sitter's ex-
act identity has been lost. He obvi-
ously was a man of means in middle
age about 1845.

Like so many of Bounetheau's por-
traits at mid-century, this miniature
displays the artist's competence for a
realistic, if unexciting, portrayal.
Much like contemporary oil painting,
the likeness is somber, enlivened only
by the rose colored drape in the
background.

REVEREND SAMUEL GILMAN,
1791–1859
Watercolor on ivory, 120 × 95 mm
Gift of Mrs. Charles Rae
57.60

A graduate in 1811 of Harvard Uni-
versity, Gilman attended the divinity
school as well. For the celebration of
his *alma mater*'s centennial in 1836
he authored *Fair Harvard*. He served
as rector of the Unitarian Church,
Charleston from 1819 until 1858, dur-
ing which time the interior of the
church was dramatically remodeled in
the Gothic revival style. He was one
of the primary organizers of the retro-
spective exhibition of Fraser in 1857,

and he wrote one of the biographical sketches in the *Fraser Gallery.*

The miniature is unusual in its relaxed pose and soft, slightly fuzzy colors. One explanation is that it may be a copy after a daguerreotype. The features, especially the eyes, are very sympathetic looking.

JOHN STOCK BEE, 1841–1863
Watercolor on ivory, 136 × 100 mm, 1867
Signed, under mat: H.B. Bounetheau Pinxit 1867
Gift of Valeria and Edward Chisolm, Mrs. John J. Prioleau and Mrs. Faust Nicholson
55.4.2

Colorplate II

Bee was a first lieutenant in the South Carolina Artillery during the Civil War and died from wounds sustained during the defense of Morris Island.

This miniature was done posthumously, with portions perhaps copied from a daguerreotype. The rigidly frontal position and incessantly regular stippling give the portrayal an unlifelike quality, and the clouds behind him might suggest another world. In addition, his limp left arm and his right hand against his chest may be allusions to his wounds.

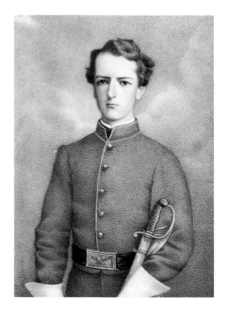

JAMES LADSON BEE, 1843–1864
Watercolor on ivory, 137 × 100 mm, 1867
Signed, under mat: H.B. Bounetheau, Pinxt 1867
Gift of Valeria and Edward Chisolm, Mrs. John J. Prioleau and Mrs. Faust Nicholson
55.4.3

A member of the Fourth Regiment of the South Carolina Cavalry, Bee died from wounds received at Cold Harbor, VA.

Apparently a pair to the portrait of John Stock Bee, this miniature must also have been done posthumously.

Rosa M. Box

Carl Ludwig Brandt
1831–1905

A native of Hamburg, Germany, Brandt received some training there before emigrating to New York in 1852. During the period 1865–1868 he returned to Europe to study the old masters. In 1872 he was elected to the National Academy and became the Director of the Telfair Academy of Arts and Sciences in Savannah in 1883. While he painted many different types of paintings, contemporary critics acclaimed the excellence of his portraits.

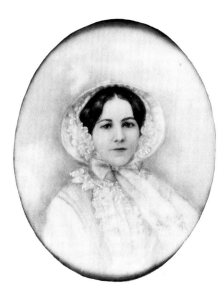

MRS. KITSON BOX
Enamel on porcelain, 72 × 57 mm, 1897
Signed, lower right: R. Box 97
Gift of the artist
46.17.1

The image, with its dominant lavender and pink hues, is emphatically feminine. Her features are more finely painted than her costume, which is almost impressionistic.

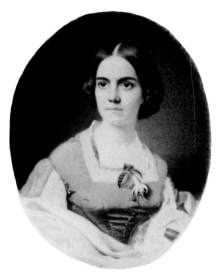

MRS. EDWARD LAIGHT
COTTENET (MARIE LOWNDES),
?–1915

Watercolor on ivory, 92 × 75 mm
Signed along right: C.L. Brandt
Bequest of Fannie Marie and Rawlins
Lowndes Cottenet
56.4.1

Mrs. Cottenet's portrait has a photographic quality to it. The light is sharp and clear and the coloring of delicate pinks and acid greens is most unusual.

John Henry Brown
1818–1891

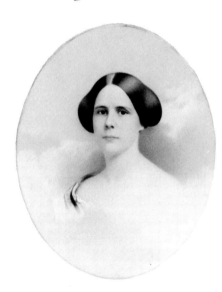

HANNAH TROUP (MRS. CHARLES MANIGAULT MORRIS)

Watercolor on ivory, 86 × 56 mm,
1855
Signed, under mat: Hannah Troup
daughter of Camilla Hayward
Brailsford & James McGilvary Troup
wife of Charles Manigault Morris of
Morrisonia NY by J. Henry Brown
Philadelphia Nov 1855 J Henry Brown
pinxit Phila. Nov. 1855
Gift of estate of Sidney Dent
75.9.2

By the mid-nineteenth century, miniaturists began to employ conventions popularized by artists painting in oil on canvas, such as the use of the drape instead of a clearly defined dress and the placement of the figure amongst clouds. The result in this case is an almost unearthly image of a rather plain woman. The colors, which are brilliantly clear, enhance this effect.

Up until 1844, Brown painted in a variety of media, but after that date he devoted himself exclusively to miniature portraiture. At the Centennial Exposition in Philadelphia he received a medal for his miniatures.

Adam Buck
1759–1833

Buck was a native of Cork, Ireland, and painted miniature portraits and watercolors there and in Dublin until 1795 when he moved to London. From his arrival until his death he exhibited at the Royal Academy. He also issued an illustrated volume on Greek vase paintings.

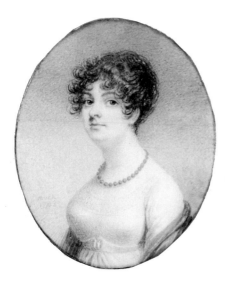

MRS. ALEXANDER GARDEN
(MARY ANNA GIBBES),
1767–1817
Watercolor on ivory, 71 × 58 mm, 1803

Signed, lower left: ABuck, 1803
Gift of Anna Gibbes
43.2.1

As a young girl Mary Anna Gibbes heroically rescued a young boy from her family's plantation while it was under siege by the British. In 1784 she married Garden, son of the noted naturalist, Dr. Alexander Garden.

A pleasing likeness, Mrs. Garden's portrait is a careful orchestration of curves and colors. The red-orange of her coral necklace is reiterated by the red shawl. Of special interest is the blue and white cameo-like buckle on her dress, which relates to Buck's interest in Greek vases.

John Carlin
1813–1891

Carlin, a deaf mute, was graduated from the Pennsylvania Institute for the Deaf and Dumb in 1825 and then studied drawing with John Rubens Smith and portrait painting with John Neagle. He spent 1838–1841 abroad in London and Paris. His miniatures are often emphatically realistic, and his portraits of children tender. He usually painted children on a small

scale designed for lockets, placed them frontally and close to the picture plane.

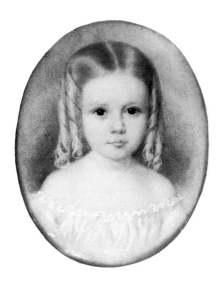

ANN HUGER LAIGHT, 1855–1914
Watercolor on ivory, 45 × 35 mm
Gift of Ann Jervey
67.24

Traditionally, this miniature has been identified as a portrait of Ann Laight, a descendant of a Charleston family who grew up in New York.

Joseph-Pierre Picot De Limoelan De Clorivière
1768–1826

A native of Nantes, France, Clorivière received his education at the College of Rennes. At the time of the French Revolution he was an officer of the guards and he always remained an ardent royalist. In 1800 he was implicated in a plot to assassinate Napoleon and in 1803 he emigrated to the United States, leaving behind his fiance who had vowed to join a convent if her beloved was spared. He traveled for several years through the South, apparently supporting himself by painting miniature portraits. In 1807 he entered St. Mary's Seminary in Baltimore and was ordained in 1812. He was assigned to the parish of St. Mary's, Charleston, then in a state of political and religious turmoil, which was not aided by Clorivière's own political convictions. After a short visit to France and London in 1815 he returned to St. Mary's, but was finally relieved of his duties in 1819 after which he successfully filled the position of Director of the Convent of the Visitation in Georgetown, D.C.

until his death. Little is known of Clorivière's artistic training, although it is presumed he was painting miniatures prior to his arrival in the United States. Typically, his portraits have opaque, usually gray backgrounds, and his handling of paint is very linear and precise. His overall style is distinctive and clearly recognizable.

Mrs. White's husband's family was from Georgia. According to Clorivière's diary still in family hands he painted numerous miniatures for Mrs. White in Augusta during May and June, 1806.

Clorivière lovingly painted Mary White's lace collar, bonnet and flowers with a delicate and precise touch. Her features, including her skewed right eye and pug nose, are directly rendered.

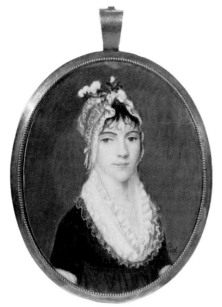

MARY ANN BELINDA O'KEEFE
(MRS. WILLIAM WHITE)
Watercolor on ivory, 70 × 55 mm, 1806
Signed, lower right: Picot
Gift of Mrs. W. E. Simms
72.10.1

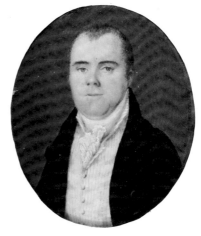

WILLIAM JOYNER
Watercolor on ivory, 64 × 55 mm, 1807
Signed, right side: P. de Clorivière 1807

Gift of Mrs. Ridgely Hunt
42.14.1

Joyner emigrated in the early 1800s
from Bristol, England and settled in
Beaufort.

With its careful delineation of hair
and clothing, Joyner's portrait is typi-
cal of Clorivière's work. Usually the
artist posed his sitters frontally, as
here, suggesting his reluctance to ac-
cept the challenges of foreshortening
and shadowing.

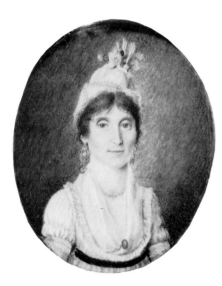

MRS. FRANCISCO XAVIER
SANCHEZ (MARIA DEL CARMAN
HILL)
Watercolor on ivory, 58 × 50 mm

Signed, lower right: P
Purchase, Morawetz Fund
37.2.4

Maria Hill of St. Augustine, FL mar-
ried Sanchez in 1787. He was a
prominent and wealthy citizen in St.
Augustine. She had the reputation of a
strong character, which is aptly por-
trayed in her portrait.

Clorivière appears to delight in
Mrs. Sanchez's finery, in particular her
pearls and long earrings. The portrait,
at one time wrongly attributed to
James Peale, was probably painted
about 1806–1807 during Clorivière's
extensive travels.

Louis Antoine Collas
1775–after 1829?

Collas was born in Bordeaux, France,
studied with a painter by the name of
Vincent, and was represented in the
1789 Paris Salon by a self-portrait.
For the period 1803–1811 he painted
at the Court of Russia in St. Peters-
burg. In 1816 and 1817 Charleston
newspaper notices and signed and
dated works attest to his presence in

the city. During the 1820s he was intermittently in New Orleans. The place and date of his death are unknown.

According to advertisements Collas painted oil portraits as well as miniatures. This is reflected in his miniatures, which often have ambitious and detailed landscape settings. The colors also are full-bodied rather than light watercolor washes. He seems to have preferred the round format.

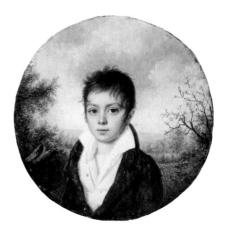

MRS. JOHN ASHE ALSTON
(SARAH MCPHERSON), 1785–1812
Watercolor on ivory, 78 mm diameter
Signed, left center: Collas
Gift of estate of Sally Middleton
60.10.1

Colorplate III

With its draped red curtain, balustrade and landscape view the composition of Mrs. Alston's miniature employs conventions popularized by seventeenth-century portraitists. However, Collas still allows the figure to dominate, with her clear flesh tones and large captivating brown eyes.

THOMAS ALSTON, c. 1806–1835
Watercolor on ivory, 74 mm diameter
Gift of estate of Sally Middleton
60.10.2

Alston grew up on family plantations along the Waccamaw River and died at age twenty-nine at Red Sulphur Springs, VA.

Collas has placed young Alston against a rustic landscape, perhaps to indicate the life of a planter. The face is sensitively drawn and more successfully modelled than that of Mrs. Alston.

RALPH STEAD AND ANNE STEAD
IZARD, 1815–1858; 1812–1892
Oil on porcelain, 186 × 231 mm,
1817
Signed, lower left: Collas, 1817
Bequest of Mrs. Julius Heyward
43.4.1

The Izard children were born into a
distinguished family of planters and
represented the seventh generation of
Izards in South Carolina. Ralph was
educated abroad and travelled exten-
sively, even to Egypt. Later he held
considerable property in St. George's
Parish.

Technically not a miniature because
of its large size and medium (painted
on porcelain) this double portrait is an
enchanting portrayal of a childhood
diversion. More than likely, Collas
staged the activity and painted the
portraits separately as neither child
looks at the other. While the land-
scape, with its rolling hills is quite
picturesque, it is not an accurate de-
piction of South Carolina terrain.

Sarah Eakin Cowan

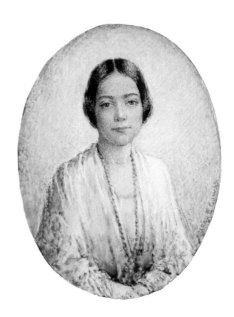

ADELE W. CONNER
(MRS. W. LUCAS SIMONS)
Watercolor on celluloid, 100 ×
75 mm
Signed, lower right: Sarah E. Cowan
Gift of the artist
54.10

As with other twentieth-century minia-
tures, this portrait appears as a re-
duced version of a larger oil portrait.
It was painted on celluloid, a modern
substitute for the more expensive and
hard-to-obtain ivory.

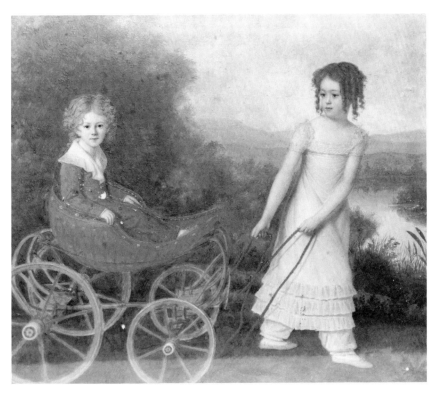

Louis Antoine Collas
Ralph Stead and Anne Stead Izard

"D"

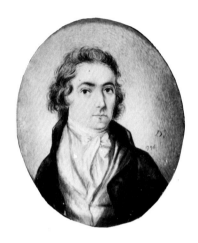

SAMUEL PRIOLEAU
Watercolor on ivory, 60 × 50 mm,
1796
Signed, lower right: D+1796
Gift of Victor Morawetz
36.7.17

Despite a distinctive style, attempts
to identify "D" have not been success-
ful. He may have been either an itin-
erant American painter or a French
immigrant. The awkward positioning
of Prioleau and the inconsistent brush-
strokes, as well as the irregular place-
ment of the date and initial, indicate
that the artist was probably un-
schooled, although the sharp model-
ling of the face and the delineation of
the features are quite accomplished.

Amélie Dautel D'Aubigny
c. 1796–1861

The wife of the painter Pierre D'Au-
bigny, Mme. D'Aubigny was a student
of Louis-François Aubry. She excelled
at miniature portraits and exhibited at
the Paris Salon 1831–1844. Promi-
nent stippling is evident in the faces
of her sitters.

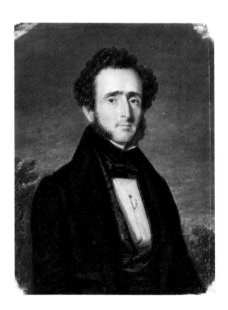

JOSHUA LAZARUS, 1796–1861
Watercolor on ivory, 125 × 95 mm
Signed, lower left: D'Aubigny

Gift of Mrs. Edgar M. Lazarus
66.1.2

Lazarus was instrumental in bringing
natural gas to Charleston. He was
president of the congregation Kahal
Kadosh Beth Elohim 1851–1861.

Like American miniatures from the
1840s, Lazarus' portrait is carefully
detailed and serious in mood. The
hint of landscape behind the figure
helps to soften the image.

Gift of Mrs. Edgar M. Lazarus
66.1.1

Phebe, a native of Liverpool, was the
wife of Joshua Lazarus.

D'Aubigny has given the fashion-
able Mrs. Lazarus an almost wistful
expression. In contrast to her hus-
band's portrait, the background is sol-
idly painted, while at the same time
the face is vividly stippled.

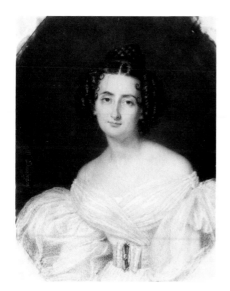

MRS. JOSHUA LAZARUS
(PHEBE YATES), 1794–1870
Watercolor on ivory, 113 × 83 mm
Signed, at left: Mme D'Aubigny

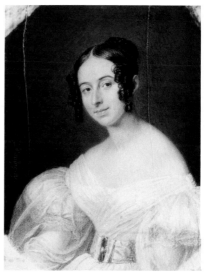

EMMA LAZARUS, 1798–1865
Watercolor on ivory, 123 × 95 mm
Signed at left: D'Aubigny
Gift of Mrs. Edgar M. Lazarus
66.1.3

Emma was the sister of Joshua Lazarus.

Emma and Phebe Lazarus appear to be wearing the same dress; this could be a true reflection of the situation, or the artist might have used the outfit as a stock item. Emma's expression is bolder than her sister-in-law's and borders on being haughty. The arc of the sitter's back is emphasized, and lends a stylish sense of elegance.

Maxime David
1798–1870

David, whose name is frequently confused with that of Jacques-Louis David, the great Neoclassical French painter, painted in Paris. He exhibited at the Salon de Paris 1834–1868, and in 1851 he was awarded the Cross of the Legion of Honor. He gained a considerable reputation for fashionable portraits.

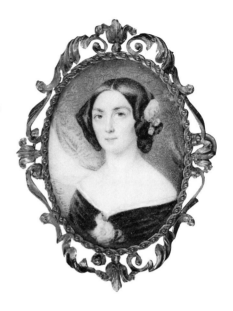

MRS. ABRAHAM VAN BUREN
(ANGELICA SINGLETON),
1816–1877
Watercolor on ivory, 35 × 25 mm
Signed, at left: M. David
Gift of Martha R. Singleton
73.5

Angelica's father, Colonel Richard Singleton, owned a large cotton plantation near Sumter, SC. She attended a seminary in Philadelphia, and after her completion there enjoyed two social seasons in Washington. Befriended by Mrs. Dolley Madison, she was introduced to President Van

Buren and his son, Abraham. A courtship ensued, resulting in their elegant wedding in November, 1838. For a wedding trip they traveled to Europe, where they were received by Queen Victoria and by Louis Philippe. Upon her return to the United States she became President Van Buren's hostess at the White House.

The miniature was probably painted in 1838 during the couple's wedding trip. It portrays an elegantly coiffed and pretty young lady in glistening colors. The intricately shaped brooch backed by mother of pearl is a proper complement to the portrait.

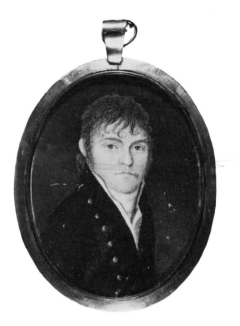

E. Deane

Little is known about the artist, except that he characteristically signed his works in block letters and that he advertised in Richmond in 1807.

MR. BREBNER
Watercolor on ivory, 60 × 45 mm
Signed, lower right: Deane, 180(?)
Gift of Sarah and John W. Pegues
82.6

Brebner lived in St. Augustine, FL where he was known for his work with the Indians.

The likeness is an intense, if dark, portrayal. The frontal pose and delineation of the hair give the portrait considerable strength.

Nicholas-François Dun
1764–1832

Dun was a native of France who painted and died in Naples. He is re-known for his exacting sense of detail and minute attention to clothes.

MRS. JOHN IZARD MIDDLETON
(ELIZA AUGUSTA FALCONET),
1793–?
Watercolor on ivory, 72 × 60 mm
Signed, lower right: Dun
Gift of estate of Sally Middleton
60.10.4

In 1810 Eliza Falconet, a native of France, married John Izard Middleton of Middleton Place. Middleton himself was an artist, mostly of Italian pano-ramas, and he has been called the "first American classical Archeolo-gist." Together the Middletons traveled extensively, especially in Italy.

Mrs. Middleton's miniature displays an elegantly dressed young woman. The soft coloring and careful detailing contribute to a genuinely feminine portrayal.

George Engleheart
1750/3–1829

Engleheart, who for a time studied in the studio of Joshua Reynolds, may have been the most prolific miniaturist of his time, painting over 4,800 por-traits. He is known to have painted George III twenty-five times and he served as Miniature Painter to the King from 1790. He maintained an account book, in which five of the CAA miniatures are listed. He ex-hibited regularly at the Royal Acad-emy 1773–1822, and came to rival the fashionable Cosway. However, in contrast to Cosway's sophisticated bravura, Engleheart's style is charac-terized by a simple and honest direct-ness. His sense of coloring was whole-some, oftentimes using a brilliant blue for the background.

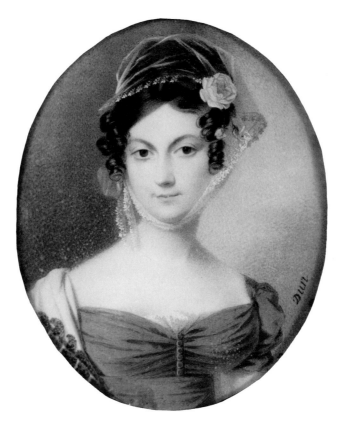

Nicholas-François Dun
Mrs. John Izard Middleton

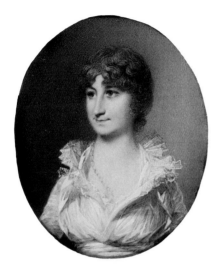 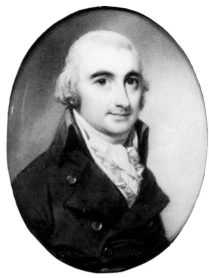

MRS. BENJAMIN STEAD, JR.
Watercolor on ivory, 64 × 54 mm
Purchase, Morawetz Funds and
Friends of CAA
39.4.10

Two portraits of Mrs. Stead are listed
in Engleheart's account book, one for
1789, the second in 1793, as "Mr.
and Mrs. Steed" [sic].[1] Slight discrep-
ancies in coloring (hers is gray, his
blue), and in scale (she is placed fur-
ther back, thus is smaller than he is),
suggest the portraits were not de-
signed as a pair. Stylistically, her por-
trait is more linear, especially in the
hair and the crisp folds of her dress.

1. George Williamson, *George Engleheart*, New
York, 1902.

BENJAMIN STEAD, JR.
Watercolor on ivory, 69 × 55 mm
Purchase, Morawetz Fund and
Friends of CAA
39.4.9

One of three portraits listed in the ac-
count book, this miniature may date
to either 1793 or 1797. It shows Stead
with powdered hair, still fairly long
and worn over his ears. The cool blue
tones and emphasis on the large
bright eyes are typical manifestations
of Engleheart's style.

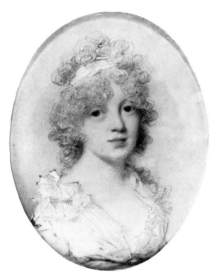

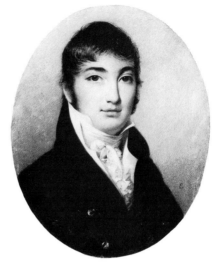

PENELOPE OGILVY ORDE
Watercolor on ivory, 55 × 43 mm
Gift of John G. Rousseau in memory
of Iris Orde Rousseau and Thorleif
Rousseau
81.10

Engleheart's account book records several male sitters with the name Ord (sic). In 1794 a Miss Ogilvy sat for a portrait which may in fact be this one. It is contained in an elaborate two-sided ivory patch box. The portrait has the wistful expression so typical of Engleheart's work, combined with especially spontaneous brushwork.

RALPH STEAD IZARD, 1783–1816
Watercolor on ivory, 85 × 68 mm
Signed, lower right: E
Bequest of Mrs. Julius Heyward
43.4.2

Born in Charleston, Izard was studying abroad in 1802 and 1803 when his portraits were painted. He returned to the Pee Dee region of South Carolina where he owned extensive property devoted to rice. The father of Ralph Stead and Anne Izard, he died at age thirty-three.

Two portraits of a Mr. Izard are listed by Engleheart in 1802 and 1803. It is difficult to determine which was painted first, and if the second was a mere replica.

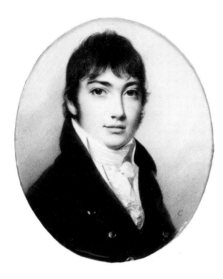

RALPH STEAD IZARD, 1783–1816
Watercolor on ivory, 80 × 65 mm
Signed, lower right: E
Purchase
39.4.7

Very possibly the second portrait painted, this miniature may be a replica of the first with variations: the hair is fuller, especially on the forehead, and the whole characterization is more intensely modelled. It is possible that Engleheart noted the maturing of young Izard, who would have been nineteen in the first portrait.

BENJAMIN STEAD, JR.
Watercolor on ivory, 60 mm diameter, 1803
Signed, lower right: E; on verso:
G. Engleheart/Pinxit 1803
Purchase
39.4.8

Colorplate IV

Painted either six or ten years after the earlier likeness, this portrait shows a slightly older, more wrinkled Stead, with a more natural and shorter hairdo. As in the earlier portrait, the dark eyes are a focal point. The setting of the portrait on the lid of an ivory snuff box adds a note of luxury.

Robert Field
c. 1769–1819

A native of Gloucester, England, Field studied at the Royal Academy, London before emigrating to this country in 1794. In England he published mezzotints, but while in America (Philadelphia 1795–1800; Washington 1800–1802; Baltimore 1802–1803; and Boston 1805–1808) he tended to specialize in miniatures. He then settled in Halifax, Nova Scotia, where he painted primarily oil portraits. His style is like Malbone's and combines

the refinement of the English with a direct honesty.

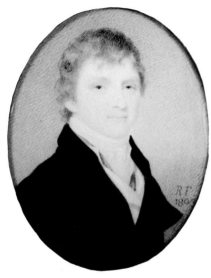

JOHN LYDE (OR LIDE) WILSON,
1784–1849
Watercolor on ivory, 78 × 63 mm,
1803
Signed, lower right: R.F. 1803
Gift of Margaret Haswell
83.5

Wilson served as Intendant of Georgetown, SC in 1811 and as Governor 1822–1824.

The portrait of Wilson is typical of Field's work, with the figure placed high, with the fine brushstrokes defining the features, and clear stippling in the background.

Charles Fraser
1782–1860

As Charleston's most distinguished native miniature artist, Fraser painted portraits of his fellow citizens for over fifty years. Practically self-taught, Fraser's only known formal training was at the age of thirteen under Thomas Coram (1756–1811), a painter, engraver, and designer of seals and currency.[1] Perhaps under Coram's direction Fraser began several juvenile sketchbooks which included copies after illustrations in travel books, tree studies, and small watercolor sketches of area plantations.[2] Despite these auspicious beginnings, he was induced to study the law under John Julius Pringle, former attorney general of South Carolina.

However, in 1818, after practicing law for eleven years, he decided to pursue a career as an artist. He initiated an account book, which he maintained with regularity until 1846.[3] Most of Fraser's lifetime was spent in Charleston, with the exception of a few trips North—to Philadelphia, Connecticut, Boston and New Hampshire—to visit family and friends. He never went abroad. As a result,

most of his sitters and patrons were Charlestonians.

Fraser was active in his community as well; he frequently gave speeches at important events, such as the dedication of Magnolia Cemetery in 1850; he was active in the fledgling South Carolina Academy of Fine Arts, and served as a trustee of the College of Charleston, his *alma mater*, from 1817 until 1860. In 1853 he delivered his *Reminiscences of Charleston*, which document the major events and cultural changes during his lifetime. He never married, and lived his entire life at 55 King Street. In 1857 his patrons and friends honored him with a major retrospective exhibition of his work—319 miniatures and 139 landscapes, still lifes and sketches.

Stylistically, Fraser's miniature portraits relate most closely to those of Malbone, who visited Charleston in 1801, 1802, and 1806, and who may have served as Fraser's mentor. There is no formal documentation of a teacher-student relationship, but they may have discussed art and more particularly miniature portraits, and Fraser would have had access to Malbone's numerous portraits of Charlestonians, even after the latter's death. That they shared a warm friendship is attested to by Fraser's 1806 visit to Newport, RI, to see Malbone, and by the fact that Fraser composed the epitaph on Malbone's tomb in Savannah.

In Fraser's earliest known portrait, of his cousin Andrew Rutledge, dated 1796 (collection of the Charleston Museum) he appears to be emulating continental examples with the use of a solid gray background and opaque handling of pigment. Apparently under Malbone's influence, Fraser's style evolved into a lighter, more delicate manner, with a carefully detailed system of stippling. This stippling technique, which may have had its origin in Malbone's crosshatching, became a hallmark of Fraser's style, and its handling is often a factor in dating the miniatures. Toward 1840 a distinct hardening of Fraser's style took place, which may have resulted from his failing eyesight, and/or from the implicit competition from the daguerreotype. In addition, from 1830 onwards Fraser painted more and more oils of landscapes, still lifes and literary themes, perhaps in response to a change in taste among his patrons.

1. George C. Rogers, Jr., "Charles Fraser Among His Friends," *Charles Fraser of Charleston*, Charleston, 1983, 22.

2. Alice R. Huger Smith, *A Charleston Sketchbook, 1796–1806*, Charleston, 1940.

3. Martha R. Severens and Charles L. Wyrick, Jr., *Charles Fraser of Charleston*, Charleston, 1983, 115–146.

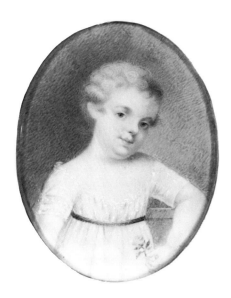

1. *Catalogue of Miniature Portraits, Landscapes, and Other Pieces, Executed by Charles Fraser, Esq., and Exhibited in "The Fraser Gallery," At Charleston, During the Months of February and March 1857,* #62.

AN INFANT

Watercolor on ivory, 79 × 63 mm, 1800
Gift of Mrs. Percy Kammerer
58.10.4

Still bearing its *Fraser Gallery* label, this miniature of a young child is number 62 in the checklist.[1] It may depict one of Fraser's nieces or nephews, and could be a posthumous likeness, which may help to explain certain awkward elements, including the pose and the unusual mustard tones. Whether the inclusion of the rose—the traditional symbol of love or martyrdom—is symbolic is not clear.

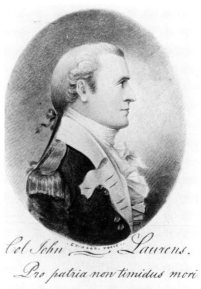

Col John Laurens.
Pro patria non timidus mori

COLONEL JOHN LAURENS, 1755–1782

Watercolor on paper, 128 × 113 mm
Signed at bottom: CFraser, Fecit
Gift of Mrs. W. R. Pomeroy, Jr.,
Carroll K. and William B. K. Bassett
68.35

After studying law in London, Laurens returned to become an aide to George Washington in 1777. He was taken prisoner in Charleston in 1780, but was later exchanged. He served as Special Minister to the court of Versailles for six months, and then took part in the siege of Yorktown. He was killed in a skirmish with British troops on the Combahee River.

As Laurens died the year Fraser was born, this obviously is a copy after an earlier profile. It may have been a design for a commemorative monument or an exercise by the young artist who greatly admired Revolutionary era patriots. Fraser did a similar pen and ink study of General William Moultrie in 1802, and might have done the Laurens portrait at the same time. Throughout his lifetime Fraser held a special devotion for American patriots, and included them among his portraits, sketches in various sketchbooks, and in his *Reminiscences of Charleston*.

JAMES REID PRINGLE, 1782–1840
Watercolor on ivory, 79 × 65 mm, 1803
Signed, on verso: painted April/1803
Gift of Victor Morawetz
36.7.11

An exact contemporary of the artist, Pringle was painted three times by Fraser. Pringle was active in political affairs, serving as President of the Senate of South Carolina, 1814–1818, as Collector of the Port of Charleston, and during the nullification controversy he was the successful Union Party candidate for Intendant of Charleston.

At one time attributed to Malbone, this portrait bears marked similarities to his miniatures, especially in the cross-hatched background and the placement of the sitter. However, it is more tentative and less sophisticated than Malbone's miniatures of this date.

REVEREND NATHANIEL BOWEN, 1779–1839
Watercolor on ivory, 70 × 58 mm, 1804
Signed, lower right: 1804
Purchase, Morawetz Fund
37.2.6

Two years older than Fraser, Bowen attended the College of Charleston and was its first graduate. He continued to have ties with the College, serving as a tutor, principal, president and trustee. He was Rector of St. Michael's Church, 1804–1809, and Bishop of South Carolina from 1818 until his death in 1839. He was described by Frederick A. Porcher as, "Grave and dignified; he became the Episcopal office better than any man I have ever seen. As a preacher he was indifferent, his sentences were all too long to be taken in by a hearer and in consequence of a tendency to stammer, he spoke with his teeth closed, so his voice was sepulchral." [1]

In its delicate touch and light coloring, Fraser's miniature of Bowen reveals Malbone's influence. The miniature was painted the same year as Bowen's appointment as rector of St. Michael's.

1. Samuel G. Stoney, ed. "Memoirs of Frederick Adolphus Porcher," SCHGM, XLVII, 1946, 49.

round format is unusual, and the characterization is stronger than others of this date.

FREDERICK FRASER, 1762–1816
Watercolor on ivory, 58 × 50 mm, 1810
Gift of Mrs. Percy Kammerer
58.10.3

The elder brother of the artist by twenty years, Frederick supervised the young artist's upbringing, and paid for his drawing lessons with Thomas Coram in 1796. Frederick inherited his father's plantation on Huspah Neck in Prince William Parish, and Fraser did a watercolor of it in his sketch book.

Fraser may have done portraits of family members as experiments or for practice. In this case, the almost

LADY WITH A NECKLACE (IDEAL)
Watercolor on ivory, 90 × 67 mm
Source unrecorded
xx 2

Perhaps used by Fraser as a demonstration piece, this ivory shows the artist completely in control of his medium. The woman suggestively offers her locket on a beautifully painted pearl necklace, which may be an invitation to the viewer to commission a portrait from the artist.

NATHANIEL RUSSELL, 1738–1820
Watercolor on ivory, 90 × 79 mm,
1818
Gift of Alicia Hopton Middleton
37.5.1

(Illustration on page 42)

Today Russell is remembered for the
fine Adam-style house he constructed
on Meeting Street 1809–1811. A na-
tive of Rhode Island, Russell came to
Charleston as a young man and be-
came a successful merchant. One of
the founders and key moving spirits of
the St. Andrew's Society, he served as
its first president.

The first entry listed in Fraser's ac-
count book, this miniature heralded
Fraser's professionalism. A penetrating
likeness of the eighty-year old Rus-
sell, it attests to Fraser's skill at char-
acter analysis. Frederick A. Porcher,
a contemporary, recognized that "if
his subject was an old man or woman
his likenesses were very felicitous."[1]
Somewhat unusual, but contributing to
the portrait's immediacy, is the use of
an almost round format.

1. Stoney, "Memoirs of Porcher," 217.

GENERAL THOMAS PINCKNEY,
1750–1828
Watercolor on ivory, 110 × 87 mm,
1818
Signed, on verso: CFraser fecit, 1818
Purchase
39.4.2

Educated at Westminster School
and Christ Church College, Oxford,
Pinckney studied law at the Middle
Temple. Upon his return to South
Carolina, he was admitted to the Bar
in 1774 and joined the First South
Carolina Regiment. During the Revo-
lution he was assigned various tasks,

Charles Fraser
Nathaniel Russell

including drilling, recruitment and engineering work on fortifications. He fought in several battles, and was wounded at Camden. Between 1787–1789 he was Governor of South Carolina; from 1792–1796 he was United States Minister to Great Britain; and in 1795 Special Envoy to Spain. During the War of 1812 he was commissioned Major General and was placed in charge of the Southeast. As a Low Country planter, he was a supporter of scientific agriculture and he encouraged crop diversification.

Fraser's portrait closely resembles an oil by Samuel F.B. Morse, except that the miniature is limited to a bust length. In 1818, the year Fraser painted the miniature, Morse spent the first of four winters in Charleston in pursuit of portrait commissions. Morse and Fraser would later become active in the founding and exhibitions of the South Carolina Academy of Fine Arts. In his version, Fraser has eliminated some of Morse's spontaneous and painterly qualities and has made Pinckney appear more vigorous. It is the fourth miniature listed in the account book, for which Fraser received $100, an unusually high sum.

DR. WILLIAM DRAYTON, 1743–1820
Watercolor on ivory, 92 × 75 mm, 1818
Signed on verso: C. Fraser fecit Oct 1818
Bequest of Mrs. Leger Mitchell
44.5.1

Born at Drayton Hall, the handsome Palladian home built by his father on the Ashley River, Drayton studied medicine at Edinburgh, where he was graduated in 1770. During the Revolution he was commissioned captain in the South Carolina Artillery Regiment and later became a member of the Society of Cincinnati. In 1785 he was elected Lieutenant-Governor.

This is a strong characterization, enhanced by the unusual three-quarter pose and the intensity of the Prussian blue coat. A likeness of Dr. Drayton is the twelfth entry in Fraser's account book.

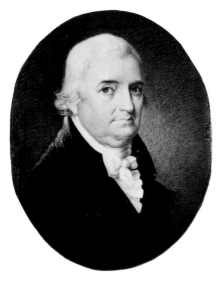

GENERAL CHARLES
COTESWORTH PINCKNEY,
1746–1825
Watercolor on ivory, 100 × 78 mm
Purchase
39.4.1

Like his younger brother, Thomas, Charles Cotesworth studied at Westminster, Christ Church College, Oxford and Middle Temple. Admitted to the Bar at Charleston in 1770, he became active in local affairs. In 1776 he served as an aide to General Washington at Brandywine and Germantown and, in 1780, was commander of Fort Moultrie during the British attack. In 1783 he was elevated to the rank of General. As a special envoy to France 1796–1797, he was involved in the X, Y, Z Affair. As a Federalist he was the unsuccessful candidate for Vice-President in 1800 and President in 1804 and in 1808. He was President General of the Society of Cincinnati 1805–1825.

Fraser held Revolutionary War Generals in high regard, and in his *Reminiscences* (1854) even described many of them. He authored the epitaph on Pinckney's memorial in St. Michael's Church, and noted, ". . . with all the accomplishments of the gentleman he combined the virtues of the patriot and the piety of the Christian." Because of its unusual painted oval format, the miniature may be a copy or a version of another work. The dark, purplish tones contribute to a somber, almost poignant expression. Two miniatures of Pinckney are listed in the account book for 1819.

The impression of the portrait is one of large proportions, due to the placement of the sitter so close to the edge of the ivory. The use of the white collar and dress, and the delicate coloring of the shawl soften the portrayal. In 1819 Fraser received $60 for a portrait of Mrs. King.

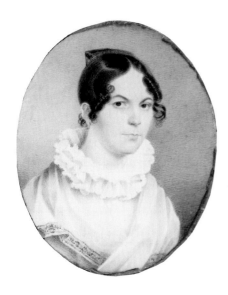

MRS. MITCHELL KING
(SUSANNAH CAMPBELL),
1791–1828
Watercolor on ivory, 97 × 80 mm,
1819
Gift of the family of Philip Porcher
Mazyck
66.23.1

Susannah Campbell was the first wife of Judge Mitchell King, a distinguished Charleston jurist and longtime President of the Board of Trustees at the College of Charleston. Fraser frequented the Kings' fine house, where the artist and judge discussed legal, artistic and cultural matters. Judge King was a longstanding patron of Fraser.

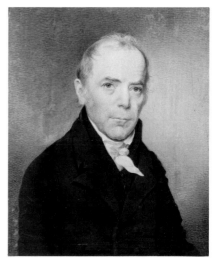

PHILIP GADSDEN, c. 1761–?
Watercolor on ivory, 102 × 84 mm,
1819
Signed, on verso: Charles Fraser fecit/
Jany 1819
Bequest of Mrs. Mary Porcher
Gadsden
55.14.2

Gadsden was held prisoner in St. Augustine in 1780.

Like the portraits of Russell and Weston, Fraser's portrait of Gadsden is a sensitive likeness of an older man. Here, however, the positioning is more direct, so that the viewer looks him in the eyes, and nothing else in the composition is distracting. In 1819, Fraser received $60 for this portrait, slightly more than usual.

A planter from Prince William Parish, McPherson served as the commanding officer of the South Carolina Militia. He was also President of the South Carolina Jockey Club.

Fraser's portrait is a direct and forceful portrayal. The stippling is especially noticeable on the face. The miniature is listed in the account book for 1819 for $50.

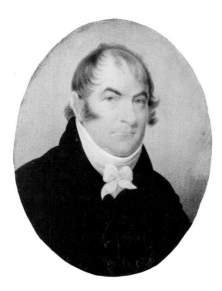

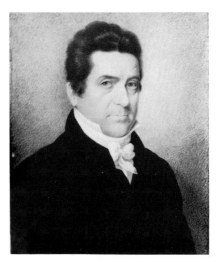

COLONEL JAMES ELLIOTT
MCPHERSON, 1769–1834
Watercolor on ivory, 90 × 75 mm,
1819
Bequest of Martha Blake Washington
34.9.1

JUDGE CHARLES JONES
COLCOCK, 1771–1839
Watercolor on ivory, 100 × 83 mm,
1819
Bequest of Annie T. Colcock
23.2.1

A graduate of Princeton College, Colcock combined a career of law and public service. Admitted to the Bar in 1792, he served as Solicitor of the Southern Circuit (1798), and then in the House of Representatives 1806–1808. He was appointed Judge of the Court of Appeals in 1824.

A particularly severe and forceful portrayal, this miniature is not softened by color or handling. "Judge Colcok [sic] . . . $50" is listed in the account book under 1819.

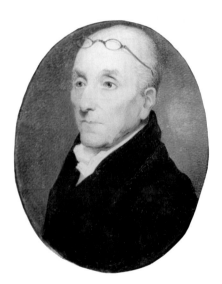

DR. ALEXANDER BARON, 1745–1819
Watercolor on ivory, 85 × 70 mm, 1819

Signed, on verso: Ch.Fraser fecit/1819
Purchase, Kammerer Fund
59.29

Born in Scotland, Baron attended College at Aberdeen and Medical School at Edinburgh. In 1769 Baron came to Charleston, and over the next decades he acquired an extensive practice which included a specialty in obstetrics. He was one of the founders of the Medical Society of South Carolina and served for twenty-eight years as president of the St. Andrew's Society, the oldest charitable society in the state.

One of three versions, this portrait varies slightly from the others, presenting him more in profile. The spectacles are on his forehead in all three, indicating perhaps a peculiar habit of the doctor. As Dr. Baron died January 9, 1819, it seems likely that this version was painted posthumously. The color is somber and the stippling somewhat methodically applied.

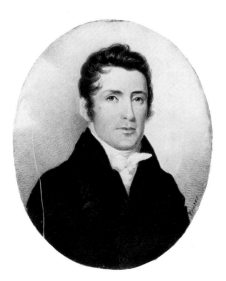

painted a portrait of Mr. Snowden for $50, as recorded in the account book.

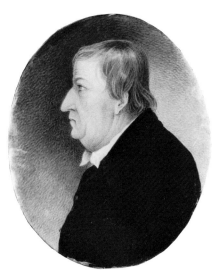

REVEREND CHARLES BLAIR
SNOWDEN
Watercolor on ivory, 90 × 75 mm,
1819
Signed, lower right: Fraser
Bequest of Mrs. Yates Snowden in
memory of Yates Snowden
39.5.2

A graduate of Yale College in 1804,
Snowden became rector of St. Stephen's
Parish in 1810, where he served for
seven years. He then ministered to
congregations in the Pineville, SC area.

The influence of Malbone continued
in the first miniatures Fraser did as a
professional. In particular, the cross-
hatched background relates to Mal-
bone's treatment. In 1819 Fraser

THOMAS HORRY, 1748–1820
Watercolor on ivory, 95 × 80 mm,
1820
Signed on verso: copied from a pencil
sketch/ CFraser pinx. 1820/ Feby 21
Purchase, Kammerer Fund
67.10.1

As a former member of the Commons
House, Horry was elected to the Pro-
vincial Congress in 1775. He was a
member of the constitutional conven-
tion which ratified the Federal consti-
tution, and was active in formulating
the state's constitution.

Fraser painted few profile portraits and, in general, they appear to be copies. Profiles had been made popular by the artist Charles Balthazar Julien Fevret de Saint-Memin, who used a specially designed tracing machine and who had been in Charleston 1808–1809. Horry's likeness is uncharacteristically unflattering, with its wrinkles, beak-like nose, stringy hair and humped back. This portrait could be the one listed for 1820 simply as "Mr. Horry . . . $50."

Watercolor on ivory, 97 × 80 mm, 1820
Signed, on verso: Painted by Charles Fraser, May 1820
Gift of Victor Morawetz
36.7.18

Mrs. Prioleau was eighty-five when Fraser painted her portrait. She was the daughter of Catherine Cordes and the daughter-in-law of Samuel and Providence Hext Prioleau. During the siege of Charleston by the British in 1780 Mrs. Prioleau and her child were sent to Philadelphia while her husband was imprisoned at St. Augustine.

Like several other portraits of this period, the likeness of Mrs. Prioleau is a sensitive study of an older person. With few distractions, Fraser makes the viewer concentrate on the sitter's face with its strong, dark eyes. The warm hues of the background enhance the humanity of the subject. Fraser was paid $50 for this portrait, which is listed in the account book.

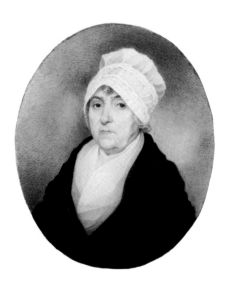

MRS. SAMUEL PRIOLEAU
(CATHERINE CORDES),
1745–1832

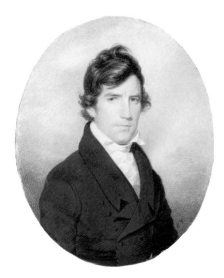

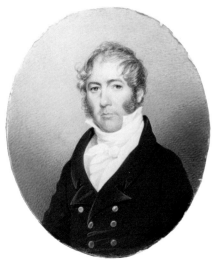

JOHN HUGER II, 1786–1853
Watercolor on ivory, 93 × 75 mm,
1820
Signed, lower right: CF; on verso:
Fraser 1820/never remove this paper.
Gift of Fannie Marie and Rawlins
Lowndes Cottenet
51.6.2

This especially fine portrait is remi-
niscent of Malbone's Charleston mini-
atures, particularly in its use of a
bright blue sky with gray clouds and
in the careful delineation of the
face—the slight scowl, the wrinkle to
the right of Huger's mouth, and the
cleft chin.

BENJAMIN BURGH SMITH,
1776–1824
Watercolor on ivory, 90 × 75 mm,
1820
Bequest of Dr. Burgh S. Burnet
74.17

Smith performed the duties of magis-
trate in Adams Run, SC.

Typical of Fraser's portraits of suc-
cessful men, the likeness of Smith is
straightforward and pleasing. The
stippling is neat and unobtrusive.
"Mr. BB Smith$50" is listed in
the account book for 1820.

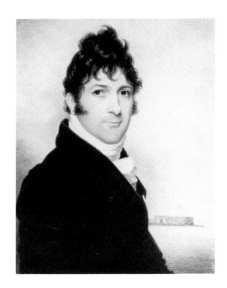

JAMES REID PRINGLE, 1782–1840
Watercolor on ivory, 108 × 88 mm,
1820
Signed, along left: CFraser; on verso:
painted by C. Fraser 1820
Gift of Victor Morawetz
36.7.10

(For a biography see Fraser's 1803
portrait of Pringle.)

A comparison with Fraser's 1803
portrait of Pringle reveals the in-
creased maturity of both sitter and art-
ist. Because of Pringle's position as
Collector of the Port, Fraser has in-
cluded a glimpse of Castle Pinckney
in Charleston's harbor to the right of
the sitter. This unusual use of a land-
scape view seems to be Fraser's first
attempt in a portrait.

Stylistically, the miniature is more
crisp than the earlier version, both in
terms of characterization and handling
of the paint. Bounetheau later did
a copy of this miniature as well as
Fraser's c. 1840 portrait of Pringle.

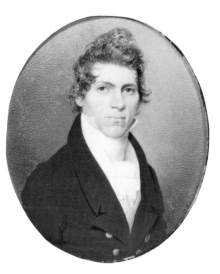

CHRISTOPHER GUSTAVUS
MEMMINGER, 1803–1888
Watercolor on ivory, 95 × 79 mm,
1823
Signed, lower right: Fraser
Purchase, Kammerer Fund
68.17

Left an orphan at age four, Memminger was raised by Governor Thomas Bennett, who taught him law. As a Unionist, Memminger spent four years in the South Carolina House of Representatives, but later served the Confederacy as Secretary of the Treasury 1861–1864. In 1854 he was appointed to the City of Charleston School Board and was instrumental in improving the quality of public education.

In this portrait Fraser has convincingly rendered the structure of Memminger's face, and the end result is a perceptive likeness. Fraser was paid $50 for the miniature in 1823.

SELF-PORTRAIT
Watercolor on ivory, 110 × 90 mm, 1823
Signed, on verso: C. Fraser AE 41 painted 1823.
Gift of J. Alwyn Ball
20.2.1

Colorplate V

This is Fraser's only known self-portrait in watercolor on ivory. On his 1824 trip to Boston, Fraser took his *Self-Portrait* to the studio of Gilbert Stuart, the distinguished portraitist. In a letter to his sister, Fraser described the great painter's reaction: "I showed him my picture and he appeared delighted with it. Indeed he said that he scarcely or never had seen a head on ivory which he preferred to it. If he had said nothing I would still have been much flattered, for he held it in his hands a half hour, looking at it."[1]

In the portrait he shows himself with a book—suggesting his background in the law and his skills as an author and orator, rather than as a painter. The column to the right became a standard motif for his most ambitious portraits. The curly, wispy hair is reminiscent of contemporary portraits by his friend Thomas Sully, but the totality lacks Sully's romantic fervor. The skewed gaze may be a physical defect, or more likely, a result of the difficulty Fraser had painting himself.

1. Charles Fraser to Susan Fraser 9 September, 1824, Winthrop-Fraser Papers, SCHS.

before 1500. The account book lists "Mr. Weston . . . \$50" in 1824.

Weston's portrait is one of the most memorable likenesses of old age. The position of Weston's head looking down may have been typical of the sitter or may have been the invention of the artist. In any event, it is striking and unique. The rumpled hair and clothing help to complete the portrayal of a distinguished man at an advanced age.

H. F. PLOWDEN WESTON,
1738–1827
Watercolor on ivory, 97 × 82 mm, 1824
Signed, lower right: CF; on verso: Plowden Weston Esq AE 85 6 months painted by Charles Fraser Charleston SC May 1824
Purchase, Kammerer Fund in memory of Helen McCormack
74.4

A native of England, Weston was a planter at Hagley on the Waccamaw River. He was an active ecclesiologist which may explain his early patronage of a Gothic-style parish church on his property. In addition, he was a bibliophile who printed fine editions and collected manuscripts and books printed

DR. JOSEPH JOHNSON,
1774–1862
Watercolor on ivory, 95 × 80 mm, 1825
Gift of John F. Maybank in memory of John F. and Eleanor Johnson Maybank
84.5

Dr. Johnson was a noted Charleston physician as well as historian and author of *Traditions and Reminiscences Chiefly of the American Revolution in the South.*

Like other portraits of the mid-1820s, Johnson's miniature is a meticulously painted and penetrating likeness. The face, in particular, is strongly modelled with convincing highlights on the eyes and the nose. Johnson's miniature is the first one listed in the account book for 1825.

Faulkner
58.30.1

A native of Massachusetts, Haskell was a Major in the Continental Line of Massachusetts from 1776–1784. He then settled in South Carolina.

Fraser's miniature is a copy after a portrait by Walter Robertson now in the Carnegie Museum, Pittsburgh. Fraser followed the original in general, but altered the position of the body so that it is straighter and less lively. In addition, Fraser's brushstrokes are more prominent. Fraser noted in 1826 "Copy of Robertson's picture of Mr. Haskell . . . $35."

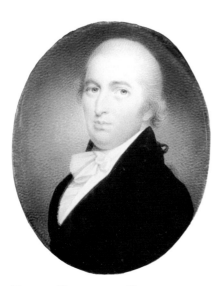

MAJOR ELNATHAN HASKELL, 1755–1825, after Walter Robertson
Watercolor on ivory, 75 × 62 mm, 1826
Bequest of Marianne Gaillard

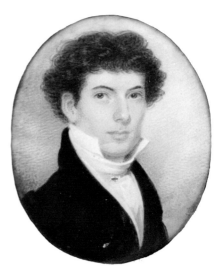

HENRY BROUGHTON MAZYCK, 1806–1835

Watercolor on ivory, 53 × 44 mm, 1826
Signed on verso: CFraser 1826
Bequest of Susan G. Mazyck
38.11.1

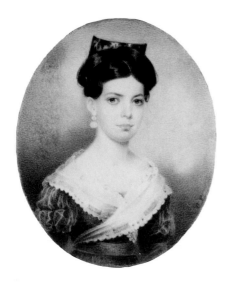

MRS. HENRY BROUGHTON
MAZYCK (SUSAN DOUGHTY
GAILLARD), 1806–1832
Watercolor on ivory, 98 × 83 mm, 1826
Signed, on face: CF; on verso: CFraser pinxit Charleston SC June 1826
Bequest of Susan G. Mazyck
38.11.2

A planter of Huguenot descent, Mazyck is associated with Fairlawn and Mulberry plantations.

Both Mazyck and his wife were painted in 1826, Fraser receiving $30 for *his* portrait in the smaller locket size, and $40 for *hers*. The size discrepancy may be explained by the fact that *his* likeness was intended to be worn by *her*. Stylistically, both are freshly rendered, showing Fraser in complete command of the stippling technique. The blue tones of both also harmonize.

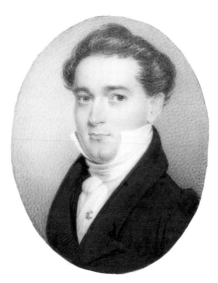

WILLIAM ANDREW JOHNSTONE, 1805–1864
Watercolor on ivory, 56 × 46 mm, 1826
Gift of Henry W. Johnston, Jr.
71.11

Johnstone, a rice planter, also frequented the community at Flat Rock, NC where he was a supporter of the Church of St. John in the Wilderness. In 1864 he was shot to death by a band of marauders near Flat Rock.

An exceptionally fine miniature, it displays Fraser's ability at capturing a likeness and giving a sense of vitality. Only the very starchy white collar detracts from the utter naturalism of the portrait. Like the portrait of Henry Mazyck it is smaller than usual and was designed for a locket. The reverse contains a lock of hair. In the account book for the year 1826 is the following entry: "Mr. Andrew Johnson 19 Sept . . . $30." The relatively low fee may be explained by the small size of the ivory, and it was probably sold without its case.

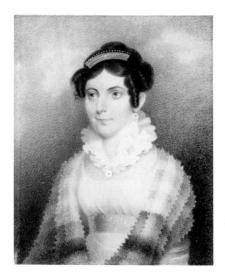

MARGARET CAMPBELL (MRS. MITCHELL KING), 1800–1857
Watercolor on ivory, 95 × 78 mm, 1826
Gift of the family of Philip Porcher Mazyck
66.23.2

The younger sister of Susannah Campbell King, Margaret married Judge King in 1830 following her sister's death in 1828.

The portrait of the second Mrs. King is more feminine and delicate than that of her sister painted seven years earlier. In particular, the gaily colored plaid shawl and soft stippling give the portrait a warmth lacking in the other. Painted in 1826, Fraser received $60 for the portrait.

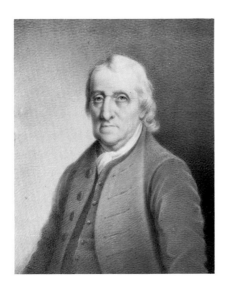

ELIAS HORRY II, 1707–1783
Watercolor on ivory, 108 × 88 mm,
1827
Signed, on verso: a copy made by
C. Fraser, July 1827
Purchase, Kammerer Fund
67.10.2

Horry was a member of the Commons
House, 1768, 1769 and 1772; Justice
of the Peace, 1776; and served as a
member of the Provincial Congress,
1775.

Fraser copied Horry's portrait from
a small oval miniature at one time at-
tributed to Rembrandt Peale and has
enlarged the composition to include
more of the sitter's body. The intense
light blue of the coat—unusual in
Fraser's own work—is the most strik-
ing characteristic of this miniature.
For 1827 the account book has the
following entry, which probably refers
to this miniature: "copy of Mr. Horry's
grandfather."

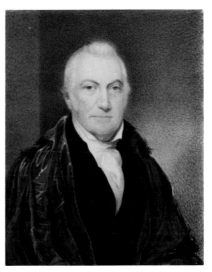

HENRY DEAS, 1770–1846
Watercolor on ivory, 115 × 94 mm
Gift of Colonel Alston Deas
76.25.1

Deas was born in Scotland, the son of
John and Elizabeth Allen Deas. He
served as President of the Senate of
South Carolina, 1828–1835, the period
covering the nullification controversy.

As Deas wears the robes of the President of the Senate, the miniature was probably painted between 1828–1835. Appropriately, it is very dignified, with Deas' white hair contrasting the somber green-gray background. The robes have been highlighted with a light gray wash.

The portrait appears to date to about 1830 when Fraser was busy with miniatures, often signed them with block letters, and was in complete control of his medium.

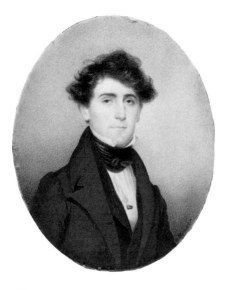

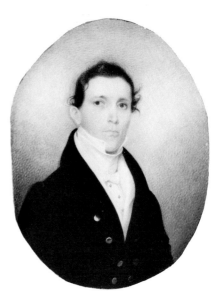

UNIDENTIFIED YOUNG MAN
Watercolor on ivory, 109 × 80 mm
Signed, lower right: Fraser
Purchase, Kammerer Fund
80.10.1

Regrettably, the identity of this young man is no longer known.

FRANCIS CHARLES BLACK,
1798–1856
Watercolor on ivory, 98 × 72 mm,
1832
Bequest of Carolina Black
59.31

A native of Beaufort, SC, Black became a Charleston merchant who specialized in importing West Indian products.

Listed in the account book for 1832, Black's miniature was painted when the sitter was in his mid-thirties. The long oval format with a simple background seems to have been favored by Fraser for portraits of young men.

The son of James Reid Pringle, young Pringle was studying medicine in Paris when he contracted influenza and died.

Fraser has employed Pringle's fashionable dress to make this an interesting likeness. The wide black collar, cravat and hairdo set off Pringle's somewhat long face, which is accentuated by the oval format. For 1834 the account book lists: "Dr. John Pringle . . . $40."

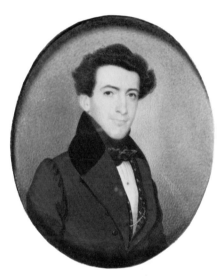

JOHN MCPHERSON PRINGLE, 1811–1837
Watercolor on ivory, 98 × 80 mm, 1834
Signed, on verso: C. Fraser/March 1834
Gift of Victor Morawetz
36.7.14

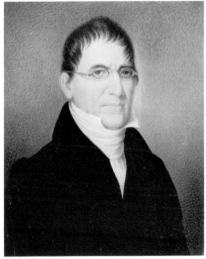

ROBERT JAMES TURNBULL, 1775–1833
Watercolor on ivory, 114 × 90 mm
Gift of the estate of Emma Bull
70.13

The son of an Englishman and a Greek woman, Turnbull was educated in London, studied law in Philadelphia, and was admitted to the South Carolina Bar in 1794. An ardent nullifier, Turnbull wrote *Essays on the Usurpations of the Federal Government*, many of which appeared in the *Charleston Mercury* under the pseudonym "Brutus." He gave numerous speeches and authored several pamphlets in defense of nullification.

Fraser, who supported the cause of the union, noted in his account book for 1832, "Era of Nullification," and that year was his least productive. The original Turnbull miniature must have been painted before his death in 1833; Fraser did three copies of it in 1835. Perhaps this is one of the copies, and as a result it is very severe. In addition, Turnbull's Greek heritage, the inclusion of diminutive spectacles, and his position on the nullification issue may have contributed to a somewhat harsh portrayal.

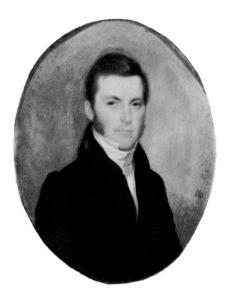

REVEREND ALEXANDER GLENNIE, 1804–1880
Watercolor on ivory, 99 × 83 mm, 1835
Signed on verso: CFraser fecit Charleston March 1835
Gift of Mrs. Aiken Simons
40.8.1

Born in Surrey, England, Glennie came to Plowden Weston's plantation Hagley in 1827 as a tutor. Ten years later he was ordained and became the rector of All Saints Church, Waccamaw.

Listed in the account book for 1835, Fraser received $40 for the miniature. Using hairstyles and fash-

ions, Fraser sets the face of the sitter off for emphasis, and poses him frontally for direct contact with the viewer.

"MISS REYNOLDS OF FENWICK HALL"
Watercolor on ivory, 98 × 80 mm
Gift of Victor Morawetz
56.12

(Illustration on page 62)

The sitter's identity is a traditional one, and may be fictional as no Miss Reynolds can be associated with Fenwick Hall, a plantation on John's Island near Charleston. The designation may result from the fact that the donor resided at Fenwick Hall and owned the miniature for at least twenty years.

Fraser has portrayed a stylishly dressed young woman about 1835. Rapidly sloping shoulders were very fashionable at that time and Fraser has accented them by the use of the oval. Likewise, her topknot is emphasized by the vertical format.

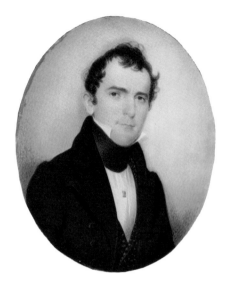

SAMUEL MAYRANT, 1806–1872
Watercolor on ivory, 98 × 81 mm, 1834 or 1839
Gift of Jasper Adams Campbell, Jr.
43.3.1

The son of Mrs. William Mayrant, Mayrant became an attorney and resided in Sumter, SC.

Mayrant's miniature is typical of Fraser's work of the 1830s, in which the light background contrasts with the dark clothing of the sitters. Fraser recorded a portrait of a Mr. Mayrant in 1834 and 1839; it is not certain which date applies to this miniature.

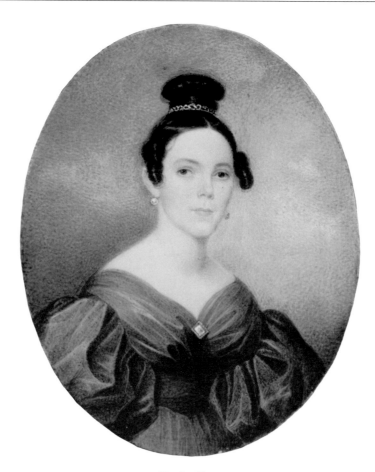

Charles Fraser
"Miss Reynolds of Fenwick Hall"

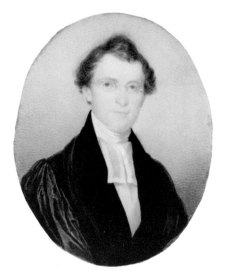
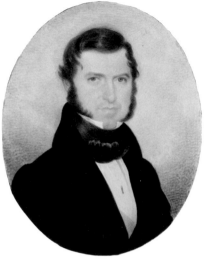

REVEREND ABRAHAM KAUFMAN,
1811–1839
Watercolor on ivory, 96 × 81 mm,
1837
Signed on verso: Painted by/C Fraser
Bequest of Abraham Kaufman
17.1.1

Kaufman served as assistant rector at
St. Philip's Church, 1837–1839 be-
fore his death at a young age.

Fraser has succeeded in attaining a
warm likeness. The crisp delineation
of the clerical collar and the wash
highlights on the robe enhance the re-
alism of the portrait. Fraser received
$40 for the miniature.

HENRY FABER, c. 1822–1859
Watercolor on ivory, 95 × 80 mm,
1837
Signed on verso: CFraser Fecit/
Charleston SC/November 1837
Gift of Isabel Bowen Heyward
23.4.1

Faber was a lawyer and planter who
lived near Adams Run, SC.

Small details such as the shirt pin
and white edges of the sitter's collar
display Fraser's mastery of miniature
portraiture. For 1837 Mr. *Joseph* Faber
is listed in the account book. Either
Fraser incorrectly entered the name,
or the identity of the sitter is mistaken.

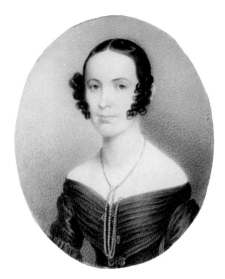

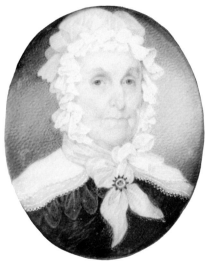

ANN DICKINSON LABORDE,
c. 1812–?
Watercolor on ivory, 94 × 76 mm,
1838
Bequest of Marion McDonald Wayne
72.5

Mrs. LaBorde's portrait appears very
controlled, especially when compared
to that of Mary Ford, painted the
same year. The simplicity of the back-
ground, the cool colors and, most im-
portantly, the lines of Mrs. LaBorde's
hairdo, dress and necklace contribute
to this severe impression. It is the
first miniature listed in the account
book for 1838.

MRS. ELNATHAN HASKELL
(CHARLOTTE THOMSON),
1769–1850
Watercolor on ivory, 70 × 58 mm,
1838
Signed, on verso: CFraser/1838
Bequest of Marianne Gaillard
Faulkner
58.30.2

The daughter of Colonel and Mrs.
William Thomson, Charlotte married
Haskell in 1791.

By the late 1830s it was unusual
for Fraser to be painting small mini-
atures in lockets, a fashion outmoded
by then. But in this instance the for-
mat was selected to correspond with
Robertson's portrait of her husband

which Fraser had copied in 1826. By 1838, Mrs. Haskell was in her late sixties, which contrasts with the more youthful portrait of her husband. Yet in technique, positioning and color, Fraser has carefully worked out a sympathetic pair. Mrs. Haskell's portrait is recorded in the account book for $40 in 1838.

MARY THEODORA FORD, ?–1847
Watercolor on ivory, 101 × 82 mm, 1838
Signed, lower right: CF
Bequest of Mrs. James Reid Pringle
45.12.1

Colorplate VI

The daughter of Timothy Ford, Mary Theodora never married.

This miniature is typical of Fraser's portraits of young women of the late 1830s and 1840s. Unlike the portrayals of young men, as a group these miniatures are more decorative and colorful, perhaps as a result of gayer clothing. The use of the variegated sky and the landscape also contribute to the colorful effects. For 1838 the account book lists, "Miss Ford . . . $50."

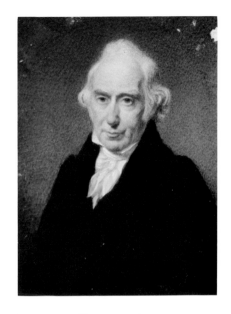

COLONEL WILLIAM ALSTON, 1756–1839
Watercolor on ivory, 85 × 67 mm
Gift of Mrs. Joseph Frederick Waring
75.14.1

During the Revolution, Alston was an aide to Francis Marion. He was a noted horse breeder and planter near Georgetown, and entertained George Washington on his Southern tour in 1791.

The Alston portraits are a little unusual in Fraser's oeuvre and have led some to doubt their attribution. The dark, greenish tones of the Colonel's miniature are exceptional and the

bold, frontal pose of Mrs. Alston against a solid background with a small sliver of landscape has few parallels. The stippling, however, and the sensitive rendering of character are within Fraser's capabilities. The colonel's pose relates to that of Plowden Weston, and may have been selected because of Alston's blindness.

With her mother, the Revolutionary heroine, Rebecca Motte, Mary Motte was kept captive in her own house by British officers during the Revolution. Her obituary stated, "The leading trait in Mrs. Alston's character, was a pure and disinterested benevolence. To do good to others was the business of her life. . . ."[1]

Mary Motte became Colonel Alston's second wife in 1791 and they had six children.

1. *Courier*, 28 November, 1838.

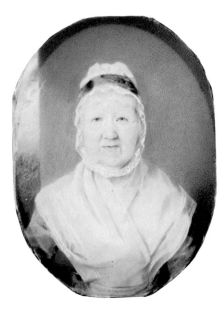

MRS. WILLIAM ALSTON (MARY BREWTON MOTTE), 1769–1838
Watercolor on ivory, 87 × 62 mm
Gift of Mrs. Joseph Frederick Waring
75.14.2

MRS. WILLIAM ALSTON (MARY BREWTON MOTTE), 1769–1838
Watercolor on ivory, 107 × 88 mm, 1839
Purchase, Kammerer Fund
66.22

Fraser's miniature is one of several careful copies of Samuel F.B. Morse's oil portrait of c. 1820. As with most of Fraser's copies it is very close to the original. In turn, Thomas Sully used Fraser's miniature for a version he painted on canvas in 1846.

In this fresh likeness of a young woman in her mid-teens, Fraser has used the outdoor setting and flowers—which include jasmine, pansies and, significantly, roses—to enliven the portrait. As in the portrait of Mary Ford, however, there seems to be little insight into the sitter's character. This may be because of a shortcoming on Fraser's part, or because of the reserve expected of a proper young lady. "Miss Rosa Pringle . . . $50" is listed in the account book for 1839.

ROSAMOND MILES PRINGLE,
1823–1919
Watercolor on ivory, 100 × 78 mm,
1839
Signed, at left: CF
Gift of Victor Morawetz
38.20.1

Rosamond was the daughter of James Reid Pringle. Never married, she lived to be ninety-five.

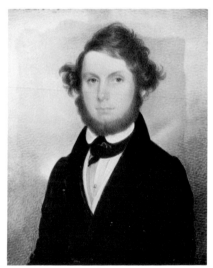

NATHANIEL BARNWELL
HEYWARD, III, 1816–1891
Watercolor on ivory, 94 × 77 mm
Bequest of Julius Heyward
24.4.8

Heyward was born in Beaufort, and was educated at Yale. He was a rice planter who served for a short time in the state senate.

Typical of the later rectangular format used by Fraser, the miniature continues in the tradition of fine likenesses of handsome young men. In this instance, Fraser has offered some variety in the use of the mottled blue-pink sky. Numerous entries for Mr. Heyward recur in the account book; most likely this one was done in 1839.

Among Mrs. Mayrant's thirteen children was Samuel Mayrant, whom Fraser painted in the 1830s. She lived in Sumter, SC, with her husband who was a prominent planter.

The format of Mrs. Mayrant's portrait is reminiscent of a type used by Samuel F. B. Morse for older women. The white bonnet and shawl serve to set off the face, while the red chair adds a comfortable feeling of warmth. The miniature is traditionally dated to 1842, which is probably erroneous. A more correct date would be 1840.

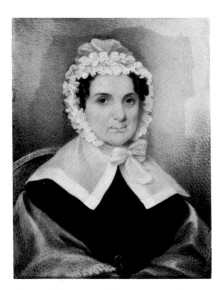

MRS. WILLIAM MAYRANT (ANN RICHARDSON), 1771–1840
Watercolor on ivory, 93 × 72 mm
Gift of Mrs. George H. Whipple
67.31.1

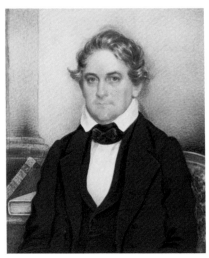

JUDGE ROBERT BUDD GILCHRIST, 1796–1856
Watercolor on ivory, 118 × 92 mm, 1841

Signed, at left: CF 1841
Bequest of Emma Gilchrist
29.1.2

A graduate of South Carolina College,
Gilchrist studied law in the office of
Keating Simons, and later practiced
as a partner of John S. Cogdell, his
brother-in-law. Between 1831 and
1839 he served as district attorney
for South Carolina and then became a
judge for seventeen years in the dis-
trict court of South Carolina.

Appropriate to Gilchrist's position
as a judge, Fraser has depicted him
with books. The column—which
Fraser had used in his *Self-Portrait* of
1823—recurs most frequently in por-
traits of distinguished lawyers and
may be Fraser's way of paying respect
to his former profession. Like other
portraits of the 1840s, there is a sense
of remoteness, derived in part from
the fact that the sitter is placed back,
away from the frontal picture plane.
The account book records for 1841
"Judge Gilchrist . . . $45."

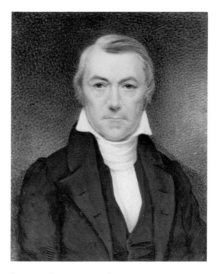

JOHN STEVENS COGDELL,
1778–1847
Watercolor on ivory, 100 × 82 mm
Bequest of Mrs. Leger Mitchell
44.2.4

Cogdell was a close friend of Fraser
and, like him, was both lawyer and
artist. Admitted to the Bar in 1799,
he also served in the South Carolina
House of Representatives (1810–
1818) and became Comptroller Gen-
eral of the State in 1819. In 1832 he
was elected President of the Bank of
South Carolina. As an artist he was a
painter—of religious subjects, such as
the Crucifixion in St. Mary's Catholic
Church, as well as of portraits—and
as a sculptor he carved busts and me-

morials, such as the one to his mother in St. Philip's Church.

In Cogdell's portrait, which is traditionally dated 1841, Fraser has presented a convincing likeness of a man he would have known well. The frontal pose, which sets up direct contact between sitter and spectator, helps to reveal Cogdell's character as an intelligent, yet sympathetic individual.

Bee's second wife was Ann Jane North.

Typical of Fraser's late work, Bee's portrait has somber coloring, harsh stippling and a rigid pose. The fact that the stippling around the body and the head, in particular, is accentuated contributes to a disconcerting halo effect. Traditionally dated to c. 1845, a portrait of "Mr. Bee . . . $50" is listed in the account book for 1842.

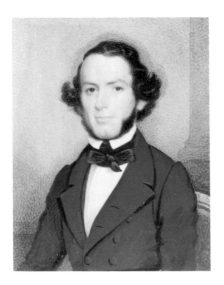

WILLIAM CATTELL BEE,
1809–1881
Watercolor on ivory, 94 × 80 mm, 1842
Gift of Valeria and Edward Chisolm, Mrs. John J. Prioleau and Mrs. Faust Nicholson
55.4.1

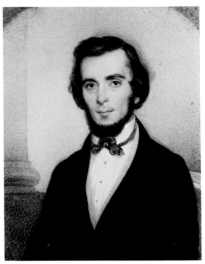

AUGUSTUS HENRY HAYDEN,
1817–1894
Watercolor on ivory, 100 × 80 mm, 1844
Signed on verso: Taken for Augustus Henry Hayden/in the 27th year of his life. Charles Fraser 1844.

Gift of Edith K. Smith
76.9.1

A native of Connecticut, Hayden came to Charleston in 1837 to become a partner in Hayden & Co., silversmiths.

The pose with the figure sitting was a standard one for the 1840s and replaced the more direct and simple ovals of the 1820s. As a result, the sitter becomes more distant and reserved, qualities that can also be seen in contemporary oil portraits.

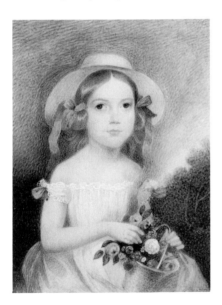

MARY BENNETT CAMPBELL,
1839–1904

Watercolor on ivory, 92 × 72 mm, 1845
Signed on verso: Painted by Charles Fraser June 1845
Gift of Anna Bell Bruns
50.6.3

Mary Campbell was an active philanthropist and upon her death her home became the Campbell Argyle Loudon Home for indigent women of Presbyterian and Huguenot descent.

The eldest of the three Campbell children whom Fraser painted in 1845, Mary would have been six years old at the time of her portrait. A sweet and delicate portrayal, Mary's figure is less awkwardly proportioned than her brother's and sister's although her head still appears too large for her body. Fraser, himself a bachelor, may have found children's portraits difficult, and the children, in turn, probably did not enjoy sitting before the sixty-three year old artist. The basket of flowers in Mary's lap and the hints of landscape to the right relate to similar details in the portraits of Mary Ford and Rosamond Pringle, and may be considered stock items.

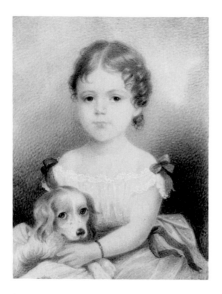

CELIA CAMPBELL, 1843–1887
Watercolor on ivory, 92 × 72 mm,
1845
Signed, on verso: Charles Fraser
Charleston/SC June 1845
Gift of Anna Bell Bruns
50.6.2

Like her sister Mary, Celia performed
good works. She was co-founder of the
House of Rest, a home for orphans too
young to be admitted to the Charleston
Orphan House.

Fraser has shown Celia with her pet
dog like the portrait of her brother.
However, her portrait is more restful
and simple. As in the other two
portraits of the Campbell children,

the variegated sky is slightly cross-
hatched and the figure is vividly
stippled.

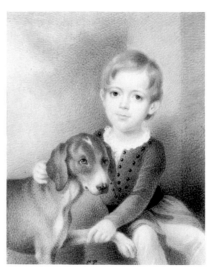

JAMES BUTLER CAMPBELL, JR.,
c. 1841–1845
Watercolor on ivory, 112 × 90 mm,
1845
Signed, lower center: CF; on verso:
Charles Fraser Charleston SC/Aug
1845
Gift of Anna Bell Bruns
50.6.1

Two interpretations regarding James
Campbell's portrait exist: that he died
shortly after the portrait was painted;
or that the portrait actually is a post-

humous likeness. In his account book Fraser noted "Mr. Campbell's son from a bust . . . $50," which may indicate that the boy was already deceased.

Like several of Fraser's other portraits of children, James' head is too large for his body, a quality which is shared by his companion, the dog. In terms of composition, the pose is uncharacteristically complicated and even suggests movement, a curiosity if, in fact, the child was dead.

MRS. WILLIAM BRANFORD
(ELIZABETH SAVAGE), ?–1801,
after Jeremiah Theus
Watercolor on ivory, 94 × 79 mm,
1845

Signed on verso: Painted/by Charles Fraser Charleston/ SC Aug 1845
Purchase, Kammerer Fund
67.10.3b

Mrs. Branford is said to have come from Bermuda and has traditionally been identified as a Revolutionary era heroine.

Fraser's miniature is a copy of an oil by Jeremiah Theus (1716–1774), painted probably about 1755. Fraser himself owned a portrait of an ancestor by Theus, about which he stated ". . . independently of its claim as a family portrait of 1750, I value for its excellence."[1] Some of Theus' characteristic harshness has been softened by the transferral to watercolor on ivory, although the stippling is quite pronounced. In 1845 Fraser recorded, "copy of Mrs. Branford, for Mr. Horry . . . $40."

1. Middleton, Margaret Simons, *Jeremiah Theus*, Columbia, 1953, 4.

softness of her medium. However, the total impression is crisper, with sharper delineations (especially in the breastplate) and more convincing reflections.

COLONEL WILLIAM RHETT, 1666–1722, after Henrietta Johnston
Watercolor on ivory, 116 × 96 mm, 1845
Bequest of Pauline Thomson
20.1.2

Rhett was a Colonel in the Provincial Militia and Vice-Admiral in the Colonial Navy. He is best known for his successful capture of the notorious pirate Stede Bonnet in 1718. He also held appointments as Surveyor and Comptroller General for His Majesty's Customs and was Lieutenant-General and Constructor of Fortifications.

In copying Henrietta Johnston's (?–1728/9) original pastel of c. 1715 Fraser has tried to capture some of the

MRS. WILLIAM JOHN GRAYSON (SUSAN GREENE), 1770–?
Watercolor on ivory, 95 × 80 mm, 1848
Signed, on verso: Painted by C. Fraser Decr. 1848, Charleston, S.C.
Gift of Mrs. Ridgely Hunt
40.7.1

Some confusion exists about the name of the sitter. A Susan Greene married William John Grayson of Beaufort in

1798. He passed away in the early years of the next century and she re-married, becoming Mrs. William Joyner. However, in the *Fraser Gallery* number 294 is listed as Mrs. John Grayson and this miniature has always been associated with that name.

The late date, 1848, of the miniature and the tender portrayal suggests that Fraser may have had a special reason for painting this portrait. Articles of clothing and the red chair help to set off the face and enliven the portrait.

LADY WILLIAM CAMPBELL (SARAH IZARD), 174?–?, after Joshua Reynolds?
Watercolor on ivory, 106 × 87 mm
Signed, on verso: copy from Sir Joshua by Chs Fraser So Carolina
Purchase, Kammerer Fund in memory of Helen McCormack
74.3

The daughter of Ralph Izard, Sarah married Lord Campbell in 1763. She moved to England in 1776 where she later died.

No documented portrait of Lady William Campbell by Sir Joshua Reynolds has been located. It is possible that one did exist, or that Fraser (as well as members of her family) mistakenly identified her portraitist as Reynolds. Clearly, however, Fraser's model was an English one, and in his copy he has employed a soft brush-stroke in order to emulate the almost impressionistic technique fashionable in English portraits at the end of the eighteenth century.

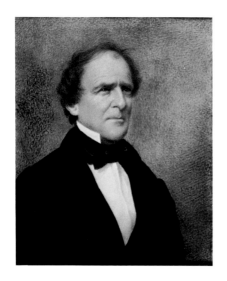

dition of color, albeit very subdued, humanizes the portrait. The last known painting by Fraser, this miniature exemplifies the tight stippling technique of Fraser's final style.

Although the daguerreotype was responsible in part for the demise of the miniature portrait, Fraser himself was intrigued by the new technique and sat before a daguerreotypist for his portrait about 1845. He appears as a confident and intelligent older gentleman, apparently at ease before the camera.

FREDERICK GRIMKÉ FRASER,
1794–1852
Watercolor on ivory, 100 × 82 mm,
1852
Gift of J. Alwyn Ball
20.7.2

The son of the artist's brother Frederick Fraser, Frederick Grimké Fraser inherited the family plantation in Prince William Parish.

Shortly after his nephew's death Fraser seems to have copied a daguerreotype taken about 1850 by C. L'Hom-Dieu. In transferring the photographic likeness to watercolor, Fraser has been loyal to the pose and features of the sitter; however, the ad-

Geslain
active 1796–1801

The artist usually advertised in the Charleston newspapers as Mr. or Monsieur Geslain, and his first name is no longer known. The notices, which appeared in 1796, 1797 and 1802, identify Geslain's teacher as "the celebrated David in Paris." Like his teacher, Geslain was severe and crisply realistic in style.

JOSEPH HINSON, 1772–1801
Watercolor on ivory, 70 mm diameter,
1801
Gift of Mrs. Julia Rogers in memory
of Joseph Hinson
35.6.1

(Illustration on page 78)

A ship captain, Hinson traveled the
route between Carolina, England and
Bermuda, and was presumed lost at
sea in 1801. The locket verso bears
the following inscription around a
monogram, J H in gold: "Taken 1 Jany
1801/aged 29 years 11 months."

The utter simplicity of the sitter
placed centrally in the round format is
very striking. The features are sharply
portrayed, including his eyes and eye-
brows, dimple, wrinkles and five
o'clock shadow. The background and
hair have distinct striations in the
paint which lend texture.

Malthe Hasselriis
1888–1970

According to legend, as a child grow-
ing up in Denmark, Hasselriis painted
his first miniature on a piano key and
was immediately captivated by the re-

sults. He studied with the Royal
Mural Painters and Decorators in
Copenhagen, but preferred "painting
in little." Upon his arrival in this
country in 1916 he became an active
member of the American Society of
Miniature Painters.

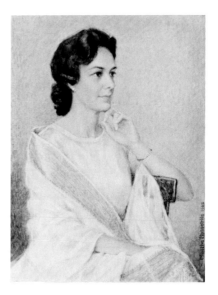

MRS. ALEXANDER F.
LEONHARDT (SERENA AIKEN
SIMONS)
Watercolor on ivory, 123 × 93 mm,
1963
Signed, along right: Malthe Hasselriis
1963
Gift of Albert Simons
72.8.3

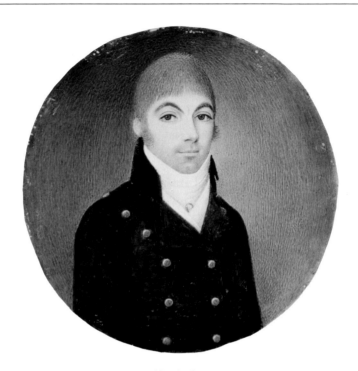

Mr. Geslain
Joseph Hinson

Mrs. Leonhardt is the daughter of Charleston architect Albert Simons. Her portrait was probably painted at the time when Hasselriis had an exhibition at the Gibbes Art Gallery, February–March 1963.

The portrait exemplifies refinement and grace. Because of its fairly ample format and half-length pose, it resembles larger portraits on canvas. The stippling is quite pronounced.

Ann Hall
1792–1863

A native of Connecticut, Hall received training in Newport, RI and New York. She exhibited at the American Academy of Fine Arts in 1817 and 1818, and beginning in 1827 at the National Academy of Design, to which she was elected its first woman member in 1833. Her miniatures generally employ a large format, are richly colored, and in their dynamic compositions relate to oil paintings.

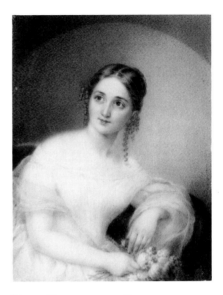

MRS. NATHANIEL RUSSELL MIDDLETON (ANNA ELIZABETH DE WOLF), 1815–?
Watercolor on ivory, 120 × 93 mm, 1842
Gift of Alicia Hopton Middleton
37.5.3

Anna deWolf was a native of Bristol, RI. Many Charlestonians summered in nearby Newport, and her husband's grandfather, Nathaniel Russell had been born there. Upon her marriage she became the daughter-in-law of Mrs. Arthur Middleton. Anna Middleton is shown wearing her wedding dress.

The pose of Anna Middleton with her arm propped up and gazing out of the portrait as if for inspiration was popularized by Thomas Sully in oil portraits. Its use by Hall gives the miniature a certain monumentality, which is tempered by the graceful lines and gentle coloring.

Pierre Henri
active in United States,
1788–1818

Henri's life exemplifies the activities of the emigrant, itinerant artist. He arrived in New York in 1788 from France, already trained as a painter, either in his native country or London. Through advertisements and city directories one can trace his presence in Philadelphia, 1789–1790, 1795, 1799–1802, 1804, 1808–1814; in Charleston, 1790–1793; New York, 1794, 1807, 1818; Baltimore, 1803–1804; and Richmond, 1804.[1]

Perhaps because of his mobile lifestyle, Henri relied upon newspaper notices as a means of communicating with his clientele. In a statement in the *City Gazette and Daily Advertiser*, he wished to convey his versatility and speed, as well as offering a guarantee:

Mr. Henri, miniature painter from Paris . . . continues to draw likenesses in miniature from the size of a small ring, to that of the largest locket; and in order to deserve the confidence of those who chose to favor him with employment, he engages from this date, to take back any likenesses not bearing a pleasing resemblance to its original. He thinks proper also to inform them that he generally takes but three sittings of half an hour each, and seldom keeps anybody longer.[2]

During his time in Charleston, Henri also offered lessons in miniature painting. By July, 1793, he began to suspect someone was trying to do him a disservice by exhibiting inferior works. Henri

. . . begs leave to inform the public that as some malevolent persons have undertaken to depreciate his likenesses by a malignant exhibition of some paintings (as done by him) he will for the future, work under the pricking of the diaphanous part of the ground of each miniature, the two initials of his name (P.H.) with the year in a manner conspicuous enough to be noticed. . . .[3]

Despite his claimed ability to paint ivories of all sizes, Henri's Charleston miniatures are generally of moderate proportions. Stylistically, they tend to share slightly mottled backgrounds and

figures with large heads placed near the top of the ivory. Facial features such as hairlines, eyebrows and the outlines of the nose and mouth are crisply delineated, sometimes with a peculiar, curling mannerism.

1. Croce, George and David Wallace, *The New York Historical Society's Dictionary of Artists in America*, New Haven, CT, 1957, 308.

2. *City Gazette and Daily Advertiser*, 23 December, 1790.

3. *City Gazette and Daily Advertiser*, 26 July, 1793.

MRS. JOHN FAUCHERAUD GRIMKÉ (MARY MOORE SMITH), 1764–1839
Watercolor on ivory, 51 × 38 mm, 1791
Signed, left center: PH 1791
Purchase, Morawetz Fund
37.2.3

Colorplate VII

Mary Smith, the daughter of a wealthy banker, married John Grimké, a planter, lawyer and judge, in 1784. Together they had fourteen children, two of whom, Sarah and Angelina, became known as the "Grimké Sisters" and emerged as outspoken feminists and abolitionists.

If anything, Henri has exaggerated the fullness of Mrs. Grimké's stylishly

curled hairdo, making it appear artificial. The face underneath, however, is freshly painted and youthful.

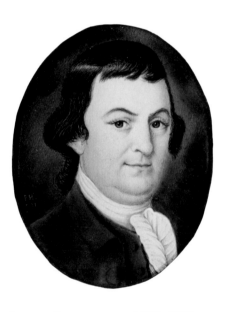

JAMES STANYARNE, 1737–1780
Watercolor on ivory, 46 × 35 mm, 1791
Signed, lower left: PH 1791
Gift of Mary Stanyarne Flud
56.9.2

Traditionally this portrait has been identified as James Stanyarne, a planter on John's Island. As Stanyarne died eleven years before the miniature was painted, this identification may be incorrect, or the miniature may be a copy after another portrait. The gold

locket bears the following inscription: "Died May 1780 aged 43."

The dark green background and rust-colored coat are unusual for Henri, and may corroborate the fact that this is a copy. However, certain curling and linear mannerisms in the eyes, eyebrows and lips are thoroughly characteristic.

A native of Scotland, Deas emigrated to Carolina in 1749 and became a successful merchant and planter. In 1759 he married Elizabeth Allen.

Probably painted in 1791, the year of Deas' death, the miniature demonstrates most of Henri's mannerisms, including the variegated background and curled mouth and eyes.

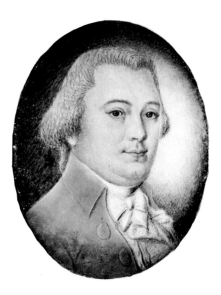

JOHN DEAS, 1735–1791
Watercolor on ivory, 46 × 35 mm
Signed, lower left: PH
Gift of Eugenia Calhoun Frost
59.23.2

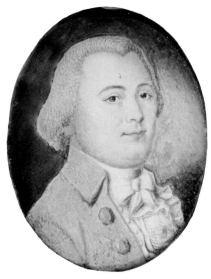

JOHN DEAS, 1735–1791
Watercolor on ivory, 45 × 38 mm
Gift of Mrs. Nicholas Roosevelt
67.30.1

This miniature seems to be an unsigned version of Henri's 1791 mini-

ature, possibly painted following the sitter's death. The coloring is more subdued.

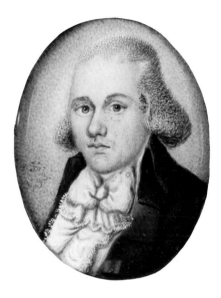

DANIEL ROBERTSON
Watercolor on ivory, 42 × 33 mm, 1793
Signed, left center: PH 1793
Bequest of Helen Robertson Blacklock 32.5.2

Compared to the miniatures signed and dated 1791, the stippling in Robertson's is bolder, suggesting that Henri's style became looser as he painted more portraits.

Nathaniel Hone
1718 – 1784

Born in Dublin, Hone traveled to Italy 1750–1752. He was active in artists' associations in London and became a founding member of the Royal Academy where he exhibited 1769–1784. He painted watercolors on ivory as well as enamels.

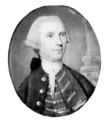

UNIDENTIFIED MAN
Enamel on porcelain, 39 × 31 mm, 1763
Signed, lower right: NH 1763
Bequest of Mrs. Amelia Emanuel 39.9.3

This small, brightly-colored enamel is typical of mid-eighteenth-century portraiture and of Hone's work. It is modest in size, unpretentious and is an unidealized characterization. One peculiarity is the off-center placement of the sitter, which permits the depiction of the column and the artist's monogram and date.

Henry Inman
1801–1846

Inman was an accomplished New York painter who apprenticed with John Wesley Jarvis. He was active in the National Academy of Design, and served as Vice-President in 1827–1831 and again during the period 1838–1844. His miniatures date primarily to the 1820s.

THOMAS FENWICK DRAYTON, 1808–1891
Watercolor on ivory, 71 × 58 mm, 1828
Signed, lower left: Inman 1828
Gift of Mrs. William Phillips
61.17

Colorplate VIII

The year his portrait was painted, Drayton graduated from the United States Military Academy. He resigned from duty in 1836, although he retained a position in the State Militia during the 1840s. He joined the Confederate Army as Brigadier-General in 1861 and commanded the unsuccessful defense of Port Royal. He was also a planter and was active in the development of the railroad, serving as President of the Charleston and Savannah Railroad.

Inman has been categorized as a "romantic realist,"[1] and Drayton's miniature bears this out. The detailing and coloring are precise and clear. However, the placement of the figure slightly above the viewer's eye level and with a slight tilt contribute to a romantic mood. The dramatic swoop of the black collar also enhances the portrayal.

1. Bolton, Theodore, "Henry Inman, An Account of His Life and Work," *Art Quarterly*, #3, 1940, 353.

AMMON BUCKLEY
Watercolor on ivory, 90 × 70 mm
Purchase, Kammerer Fund
80.10.2

Even more than the portrait of Thomas Drayton, Buckley's miniature exudes romanticism. Again, the pose is striking and, in addition, the sitter is enhanced by a vista into the landscape. The use of the fur-trimmed cape also adds considerable breadth to the figure which offsets the verticality of the oval.

Joseph Jackson
1796–1850

A native of Oxford, England, Jackson came to the United States in 1831 and three years later settled in Charleston. It seems that his success was mixed, as a writer in the *Courier* 12 August, 1847 refers to Jackson as ". . . an artist who has long resided in our city, struggling against misfortune and adversity" Perhaps for this reason, Jackson, together with his wife and son Henry, a landscape painter, turned to the repair and restoration of damaged paintings. For his abilities in this area he was frequently commended in the local press.

JOSEPH JACKSON'S SCRAPBOOK
Overall measurements: 230 × 185 mm; 37 pages
59 watercolor and 38 pencil sketches
Gift of Edmund S. Jackson
50.2.15

Evidently a working scrapbook in which Jackson collected sketches of his sitters, the book provides important information about Jackson's working methods. Some appear as the initial sketch in pencil and concentrate primarily on the facial features. Others, on cards and occasionally on ivory, are more fully worked up. Jackson may have used this latter group to entice prospective clients, as he stated in an announcement in the

Courier ". . . he will be happy to exhibit specimens of his painting, to those Ladies and Gentlemen who may favor him with their calls. Miniature likenesses highly finished on ivory of the smallest sizes, suitable for lockets, breast pins, etc."

For some time the portraits of the Greers were thought to be by Bounetheau, but upon the discovery of a sketch of Greer in Jackson's scrapbook, the attribution was clarified. Significantly, Jackson has posed Greer with a book in his right hand. Despite an attempt at casualness and the use of a landscape background, the portrait is reserved. Jackson tended toward the use of opaque pigments mixed with lots of gum arabic, which contributes to the slightly heavy quality.

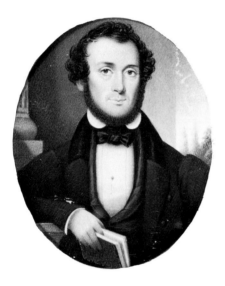

JOHN MAYNE GREER, 1807–1883
Watercolor on ivory, 78 × 64 mm
Purchase, Morawetz Fund
37.2.8

Greer was a native of Belfast, Ireland, who emigrated to Charleston in 1826. In 1838 he owned a bookstore at 135 King Street, where Jackson occasionally exhibited his work. During the Civil War he served in the reserves.

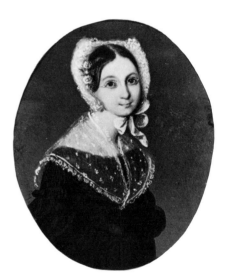

MRS. JOHN MAYNE GREER
(CAROLINE IANS HARTH),
1814–1901

Watercolor on ivory, 79 × 65 mm
Purchase, Morawetz Fund
37.2.7

Caroline Harth was the daughter of
a planter and married Greer in 1832.

Evidently a somewhat plain woman
who wore spectacles, Mrs. Greer is
portrayed by Jackson simply and hon-
estly. He has given her a more relaxed
pose than her husband's, and has de-
voted a good deal of attention to her
costume.

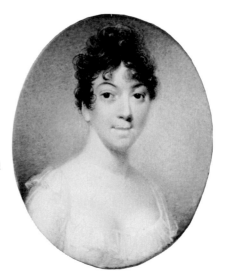

John Wesley Jarvis
1780–1840

A native of England, Jarvis settled in
Philadelphia in 1785. He served as
an apprentice to Edward Savage 1796–
1801, and then moved to New York
where he painted oil portraits and min-
iatures in partnership with Joseph
Wood. Both artists were advised by
Malbone about their miniatures. In
contrast to his oil portraits which show
robust and vigorous figures, Jarvis'
miniatures are finer and more delicate.

ELIZABETH MARY MCPHERSON
(MRS. JAMES REID PRINGLE),
1783–1843
Watercolor on ivory, 62 × 52 mm
Gift of Victor Morawetz
36.7.20

As a young girl, Elizabeth had been
painted by Henri. This portrait is be-
lieved to have been painted in New
York in 1806, where Elizabeth arrived
after the traumatic shipwreck of the
Rose in Bloom which took her father's
(General John McPherson) life.

The portrait shows a pleasing like-
ness of a young, fashionably dressed
woman. The illusion of the thin fabric
of her dress is very convincing. In
coloration and pose the miniature dis-
plays the influence of Malbone.

J. O. M.

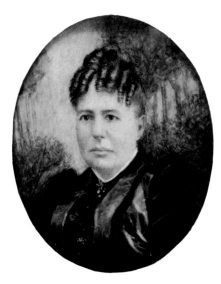

MRS. WILLIAM A. CARSON
(CAROLINE PETIGRU), 1820–1892
Watercolor on ivory, 62 × 49 mm
Signed at left: J.O.M. 1. . .
Gift of James E. Leath in memory of
Clement March
39.1.3

Caroline Carson was the daughter of
the distinguished lawyer and Unionist
James Louis Petigru and was a painter
in her own right. She studied and
copied old masters in Italy and trav-
elled extensively, even to Egypt.

Only the artist's initials are known

from the signature. The portrayal is
matronly and Victorian with the pre-
dominance of her black dress and the
lush verdant background. The portrait
may have been painted as late as the
1870s.

Edward Greene Malbone
1777–1807

Before his death in Savannah at age
twenty-nine, Malbone had attained his
reputation as America's outstanding
miniaturist. Leaving his native New-
port, RI, in 1794 as a seventeen-year-
old self-taught artist, Malbone initiated
a career which took him to the major
east coast cities: Providence, Boston,
New York, Philadelphia and Charles-
ton. He carefully recorded his success
in an account book begun in Charleston
in December, 1801.[1]

Among his friends and admirers was
Washington Allston, with whom Mal-
bone traveled to England in May,
1801. In London, he frequented the
studios and galleries, admiring more
the work of his English contemporaries
Sir Thomas Lawrence and Richard

Cosway than the paintings of the old masters. His circle of associates included the Americans Benjamin West, John Trumbull and Charlestonian John Blake White. He seems to have studied at the Royal Academy on an informal basis. In his native country he befriended numerous artists, including Anson Dickinson, Benjamin Trott and Charles Fraser.

Upon his return from England, Malbone renewed his itinerant path. His periods in Charleston tended to be his most productive. Two-and-a-half months during the spring of 1801 resulted in thirty-one miniatures and, in a five-month span from December 1801 to May 1802, he painted fifty-eight miniatures. His final visit to Charleston was in the spring of 1806, at which time he caught a violent cold which eventually contributed to his demise. Later that year, Fraser traveled to Newport where he found that "Poor Malbone is not in a condition to paint. I am afraid he is hastening to that bourne whence no traveller can return. He was ill the whole time I remained at Newport."[2]

Malbone was recognized as a refined and accomplished artist, whose miniatures had stylistic finesse. Allston, in a letter quoted by Dunlap described Malbone's genius: "He had the happy talent among his many excellencies, of elevating the character without impairing the likeness, this was remarkable in his male heads, and no woman ever lost any beauty from his hand, nay, the fair would often become still fairer under his pencil."[3] In London, John Blake White commented, "Malbone as a miniature painter stands high already, and may rank with the first in England. He is a man of uncommon taste and elegance in that line."[4] And Fraser, in the obituary he wrote for the *Charleston Times*, stated "He imparted such life to the ivory, and produced always such striking resemblances, that they will never fail to perpetuate the tenderness of friendship, to divert the cares of absence, and to aid affection in dwelling on those features and that image, which death has forever wrested from it. His style of painting was chaste and correct, his colouring dear and judiciously wrought, and his taste altogether derived from a just contemplation of nature."[5]

1. Tolman, Ruel Pardee, *The Life and Works of Edward Greene Malbone 1777–1807*, New York, 1958.

2. Charles Fraser to Susan Fraser, 9 October, 1806, Winthrop-Fraser Papers, SCHS.

3. Dunlap, *History*, II, 140.

4. Tolman, *Malbone*, 25.

5. *Charleston Times*, 27 May, 1807.

ELIZA IZARD (MRS. THOMAS
PINCKNEY, JR.), 1784–1862
Watercolor on ivory, 73 × 59 mm,
1801
Signed, lower right: Malbone 1801
Purchase
39.4.4

Colorplate IX

Eliza, the lovely daughter of Ralph
Izard, Jr., was painted twice by Mal-
bone during his December 1801–May
1802 visit to Charleston. Her mother
is identified in the account book for
December, 1801, as paying $275,
probably for three or four portraits.
During this time Eliza was being
courted by Thomas Pinckney who
was most eager for her to be painted
by Malbone. They married in Decem-
ber, 1803.

A good example of the "fair becom-
ing still fairer," the miniature of Eliza
verges on a romantic interpretation, in
the manner of Cosway. The hair softly
piled high, the faraway, dreamy gaze
and the cloudy background all relate
to the style of the English master
whom Malbone is known to have ad-
mired. However, through the brush-
stroke and coloring, Malbone has given
the sitter substance and credibility.

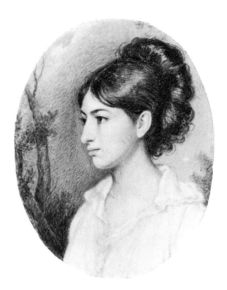

LOUISA CHARLOTTE IZARD (?),
1794–1825
Watercolor on ivory, 78 × 63 mm
Purchase
39.4.5

The identity of the sitter is not cer-
tain. She bears a resemblance to Eliza
Izard in dress, hairstyle and facial
features, and the provenance of the
miniatures is the same. It may be one
of the three or four miniatures Mrs.
Izard paid for in 1801. The identity of
Louisa Charlotte is traditional, but
probably incorrect; in 1801 Louisa
Charlotte would have been less than
eight years old. It may in fact be an-
other Izard daughter, possibly Mary
(1780?–1858?) or Patience (1786?–

1860). Tolman includes the work in his book as an "unknown young lady."

Placed almost in profile, the sitter becomes a little remote. Details in the background, such as the tree, serve to balance the composition.

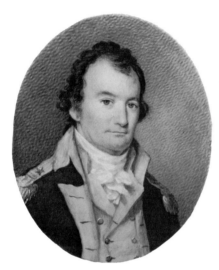

GENERAL JOHN MCPHERSON,
1756–1806
Watercolor on ivory, 73 × 62 mm
Gift of Victor Morawetz
36.7.8

McPherson served as lieutenant colonel of the 20th Regiment before being promoted to Brigadier General of the 5th Brigade. He lost his life during the shipwreck of the *Rose in Bloom*. A marble memorial carved by the

Flemish artist John Devaere commemorating the tragedy was rejected by the Scots Presbyterian Church for which it had been intended because of the immodesty of the figures, one of whom was Elizabeth McPherson. The monument is now installed at the Gibbes Art Gallery.

McPherson, wearing his uniform, is shown as a solid individual. Usually dated to 1801, the miniature may have been painted before Malbone's trip to London, after which time the portraits are lighter and more idealized.

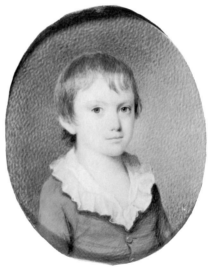

JAMES MCPHERSON,
c. 1795–1829

Watercolor on ivory, 65 × 53 mm
Gift of Victor Morawetz
36.7.9

James was the only son of General
John McPherson and appears to be
about five years old in the portrait.

The ivory of young James was at
one time framed on the reverse side
of the General's portrait. Whether this
was the original conception is not
known. James resembles his father,
especially in the shape of the lips and
eyebrows, the proportions of the head
and the intensity of the eyes. The
boy's bright red outfit, however, con-
trasts with the more somber tones of
the general's portrait. James' portrait
was probably painted at the same
time, 1801.

COLONEL THOMAS PINCKNEY,
JR., 1780–1842
Watercolor on ivory, 76 × 60 mm
Purchase
39.4.3

Colorplate IX

The son of General Thomas Pinckney,
Pinckney spent part of his childhood
in London while his father was ambas-
sador. The Society of Cincinnati paid

him the following tribute: "Inheriting
family distinction and wealth, Col.
Pinckney was early in life placed in
a situation in society which required
him to support the station of a Caro-
lina gentleman, and by his courteous
manners and generous hospitality, he
adorned that elevated and dignified
station."[1] A planter, he was interested
in scientific agriculture and was presi-
dent of the Pendleton, SC, Farmers
Society.

Pinckney had his portrait painted
during December, 1801–January,
1802. While his portrait and that of
his wife Eliza are thought of as a pair,
they were not designed to be so; his
figure is on a smaller scale, and they
have different types of backgrounds.
Malbone has dramatically accented
his portrait with the red of Pinckney's
waistcoat.

1. *Charleston Mercury*, 8 July, 1843.

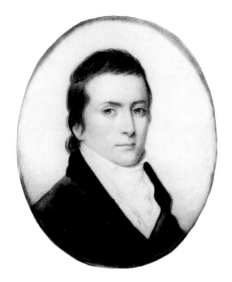
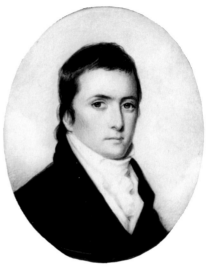

JOSEPH YATES, 1775–1822
Watercolor on ivory, 70 × 55 mm,
1801–1802
Gift of Lois Hazelhurst Fitz in memory
of Jennie Mikell Hazlehurst
82.5

A handsome and straightforward likeness, the portrait is of the type which would later influence Fraser. Tolman has identified it with the following entry in the account book, from December 1801–1802: "Joseph Yates, Sunday 10 o'clock pd. x."

JOSEPH YATES, 1775–1822
Watercolor on ivory, 72 × 57 mm,
1802
Gift of Mrs. Yates Snowden, in
memory of Yates Snowden
39.5.1

Malbone painted two versions of Yates' portrait. Tolman identified this miniature as the second one recorded in the account book, February–April, 1802. February–April, 1802.

EDWARD LAIGHT, 1773–1852
Watercolor on ivory, 80 × 69 mm,
1802
Bequest of Fannie Marie and Rawlins
Lowndes Cottenet
56.4.6

Laight served as President of the
Eagle Fire Insurance company of New
York for twenty-five years. In 1802 he
married a Charlestonian, Anne Huger.

Recorded in Malbone's account
book for December, 1802, the mini-
ature was painted in New York and
Malbone received $50. Laight's por-
trait reveals the influence of English
miniaturists in the inclined position
of the head, the faraway gaze and del-
icate transparency of the background.
However, the portrait has a robustness
and substance often lacking in En-
glish examples.

Charlotte Lorraine McCord (Mrs. Langdon Cheves, Jr.)
1818–1879

A native of Columbia, SC the artist
was an artful copyist.

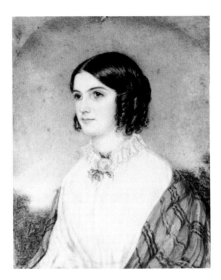

MRS. EDWARD PARKER (EMMA
MCCORD), 1830–1851
Watercolor on ivory, 106 × 88 mm,
1849
Signed, under mat: Emma Parker
1849; on verso: Oct 1849/ Painted
by her sister/ Charlotte L. Cheves
Gift of Emma Wilkins
40.6.1

Emma was the artist's sister. The pose
and conception of the portrait is based
on a miniature by George L. Saunders.
It dates from the period when mini-
atures grew larger in scale and emu-
lated oil portraits.

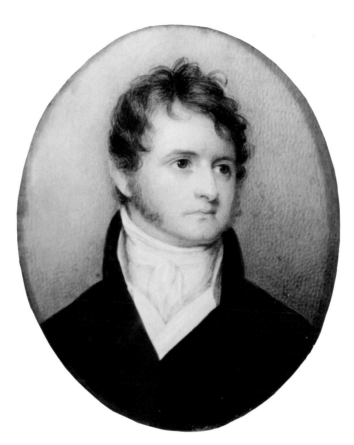

Edward Greene Malbone
Edward Laight

Eliab Metcalf
1785 – 1834

A native of Massachusetts, Metcalf suffered from ill-health most of his life. In New York directories of 1812 and 1814 he is listed as a profile and miniature painter. In pursuit of better health he traveled to New Orleans (1819 – 1821), the West Indies (1821 – 1822) and Havanna (1824 – 1833), with intermittent stays in New York.

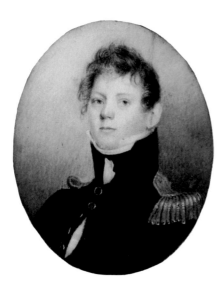

CAPTAIN THOMAS BROOM
Watercolor on ivory, 62 × 54 mm, 1816
Signed, at left: Metcalf, 1816

Gift of Mrs. R. Frank Freeman and Mrs. Llewellyn Perry in memory of Mrs. F. M. LaBruce
82.10

Broom, a captain in the U.S. Navy, served aboard the *Chesapeake*.

The likeness is a striking portrayal of a handsome young man. The somewhat elongated viewpoint adds dignity to the sitter, while the light pink background is unusual for a naval officer.

Thomas Middleton
1791 – 1863

A member of a distinguished Charleston family, Middleton was an amateur artist. He is best remembered for his 1827 wash drawing, *Friends and Amateurs in Musick* in which he depicts a group of Charleston gentlemen who ". . . frequently met at each others houses during the sultryness of a summer afternoon."[1] In addition, he copied some of the family's outstanding portraits including Benjamin West's painting of his namesake, Thomas Middleton.

1. CAA collection

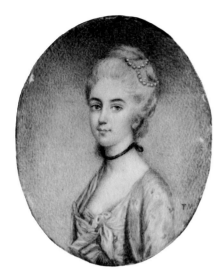

Godfrey Miller
c. 1811–1887

Miller was a miniaturist active in New York during the middle of the century.

MRS. RALPH IZARD (ALICE DE LANCEY), 1745–1832, after Henry Spicer
Watercolor on ivory, 57 × 47 mm
Signed, lower right: TM
Gift of Mrs. Victor Morawetz
38.46.1

(For Mrs. Izard see entry under Spicer.)
Except in coloring and a few details in her dress, Middleton has made a faithful copy of the Spicer enamel. However, in the transfer to the ivory medium his copy has become softer and more delicate than the original.

MRS. WILLIAM GADSDEN (CLARA PUTNAM)
Watercolor on ivory, 49 × 38 mm
Signed at bottom: G. Miller
Gift of Mrs. George C. Logan in memory of Mrs. William S. Gadsden, II
77.32

Probably painted during the second half of the nineteenth century, Mrs. Gadsden's portrait employs the fashion of showing the bare shoulders of the sitter, with the lower portion filled in with clouds. Despite a rather severe hairdo, Miller has conveyed a rather sweet expression.

Thomas Officer
c. 1810–1857

According to tradition, Officer studied
in Philadelphia under Thomas Sully.
Appparently restless, Officer was in
Mobile (1837), Philadelphia (1841–
1847), and New York (1847–1849),
where he exhibited at the National
Academy. After the Mexican War he
went to Mexico with some success and
then to Australia. He settled in Califor-
nia, and in his obituary was acclaimed
". . . in all probability the best por-
trait painter ever in California; his col-
oring is without equal; his finish in
miniatures beautiful in the extreme."
He was also credited with elevating the
level of painting in his adopted state:
"As soon as Mr. Officer began his labors
in California, a visible improvement
was noticed among the other artists of
the city. He was a worthy model."[1]
Contemporary critics praised his sense
of color.

1. *Alta California*, 9 December, 1859.

MRS. SAMUEL WILSON
Watercolor on ivory, 80 × 64 mm,
1838
Signed, lower right: T.S.O.1838 Pinxt
Purchase, Morawetz Fund
36.7.1

The severity of Mrs. Wilson's dress
style and hairdo have been countered
by the attempt at an informal pose.
However, the position of her left arm
remains awkward. Like other artists
working in the 1830s, Officer had a
tendency to use heavy pigmentation.

MRS. JOHN S. COGDELL (MARIA GILCHRIST), 1785–1858
Watercolor on ivory, 79 × 65 mm
Bequest of Emma Gilchrist
29.1.4

Emma Gilchrist was the wife of lawyer and amateur artist John S. Cogdell.

At one time the portrait of Mrs. Cogdell was attributed to Fraser, perhaps because of its association with Fraser's portrait of her husband. Like that miniature, Mrs. Cogdell's portrait is severe, with somber tones and an almost frontal pose.

James Peale
1749–1831

James was the younger brother of the noted painter Charles Willson Peale, who instructed him in painting and who generally passed over miniature portraits in deference to his brother's emerging career. At first James' miniatures resembled the small, darkly colored and linear portrayals of his brother, but gradually his style evolved into a more gracious and luminous one. He characteristically signed and dated his miniatures, which has aided tremendously in attributing works to his hand.

JARED BUNCE, 1759–?
Watercolor on ivory, 70 × 58 mm, 1809
Signed, lower left: IP 1809
Gift of Mrs. B. S. Nelson
67.34.1

Colorplate X

After unsuccessful attempts at being a merchant, Bunce took to the sea and commanded the packet *Georgia*, which did business between Charleston and Philadelphia.

Bunce's portrait fits into Peale's third and last period, evidenced by ". . . a further simplification of technique and a greater emphasis on the character of the subject. Less attention is given to detail of costume and more to a study of the face."[1] Here the characterization of the face is strong and unidealized. The background is systematically cross-hatched.

1. Jean Lambert Brockway, "The Miniatures of James Peale," *Antiques*, October, 1932, 132.

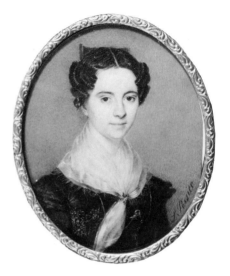

Luigi Persico

Persico was a member of an artistic family from Naples which included his brother Gennario who was also a miniaturist who worked in Philadelphia. Luigi seems to have specialized more in sculpture, and is known to have worked in Pennsylvania, at Lancaster, Harrisburg, Philadelphia and also Washington. Persico's miniature style appears typically continental, with its emphasis on bright colors and precise technique.

YOUNG WOMAN OF COTTENET FAMILY
Watercolor on ivory, 62 × 56 mm
Signed, lower right: L. Persico
Bequest of Fannie Marie and Rawlins Lowndes Cottenet
56.4.7

In its brilliant, enamel-like coloring and fine detailing, especially of the dress, this miniature relates to the work of other European miniaturists who came to this country. She wears a miniature attached to a long chain tucked into her bodice.

John Ramage
c. 1748–1802

Born in Dublin, Ramage attended the Dublin School of Artists, where he received training as a goldsmith and painter. About 1772 he emigrated to the colonies, first to Nova Scotia and by 1775 he had settled in Boston. During the Revolution he was a Loyalist and a member of the Royal Irish Volunteers, serving in Boston, Halifax and New York. He remained in New York following the close of hostilities until 1794 when he went to Montreal, where he died after several years of ill-health.

In general, most of Ramage's sitters were either Tories or were sympathetic to the British. His style is crisp and realistic, with rich coloring and strong contrasts of light. The cases for his ivories are finely chased, frequently bear a fluted rim, and probably were crafted by him.

BENJAMIN FANEUIL BETHUNE, c. 1759–1795
Watercolor on ivory, 45 × 38 mm
Gift of Mrs. Percy Kammerer
62.33.3

Colorplate XI

Although little is known about Bethune, it is presumed that he was a Loyalist (he is portrayed in a "red coat" uniform) and the miniature was probably painted in Boston.

The likeness is straightforward and unidealized, including a prominent five o'clock shadow. The emphatic red of the uniform placed against the solid dark background is also striking.

Mary Roberts
?–1761

Mary Roberts has been called "America's first woman miniaturist"[1] and together with her husband, Bishop Roberts, "the pioneer couple of professional painters working in North America."[2] Following his death in 1739 she helped to promote the sale and distribution of the engraving by W. H. Toms after her husband's *Prospect of Charles Town*, and seems to have supported herself by "face painting." What miniatures have been attributed to her are of a small format, usually somber in coloring and ruggedly realistic.

1. Frank L. Horton, "America's Earliest Woman Miniaturist," *Journal of Early Southern Decorative Arts*, November, 1979, 1–5.
2. Anna Wells Rutledge, "Charleston's First Artistic Couple," *Antiques*, August, 1947, 101.

UNIDENTIFIED CHILD, OF THE
GIBBES OR SHOOLBRED FAMILY
Watercolor on ivory, 30 × 25 mm
Signed, at right: MR
Bequest of Mrs. Amelia Josephine
Emanuel
39.9.1

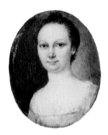

WOMAN OF THE GIBBES OR
SHOOLBRED FAMILY
Watercolor on ivory, 44 × 37 mm
Signed, center right: MR
Bequest of Mrs. Amelia Josephine
Emanuel
39.9.2

Although the precise identities of
these sitters are today unknown,
through their descent in the Gibbes-
Shoolbred family they are presumed to
be mid-eighteenth-century ancestors.

The portrayals are straightforward
and crisply delineated. The expres-
sions of both woman and child are
intent. Clothing and background are
reduced to a minimum, and coloring
consists of somber grays.

Andrew Robertson
1777–1845

A native of Aberdeen, Robertson be-
gan practicing art at fourteen. He stud-
ied with the portraitist Henry Raeburn
and upon his arrival in London in
1801 he was encouraged by Benjamin
West. He exhibited extensively at the
Royal Academy (292 works for the pe-
riod 1802–1842) and was appointed
miniature painter to the Duke of Sus-
sex in 1805. He usually signed his
work with his monogram: AR.

MRS. ARTHUR MIDDLETON
(ALICIA HOPTON RUSSELL),
?–1840
Watercolor on ivory, 91 × 70 mm,
1836
Signed, right edge: AR 1836

Gift of Alicia Hopton Middleton
37.5.2

Colorplate XII

Alicia Middleton was the daughter of
Nathaniel Russell.

Despite its attention to fashionable
frills, the portrait of Mrs. Middleton
exudes robustness. In its large format,
the use of a drapery in the back-
ground, and its rich greens and reds,
the miniature appears to imitate large
scale oil portraits—a trend that began
emerging in the 1830s.

Walter Robertson
c. 1750–1802

Sometimes known as "Irish Robertson,"
the artist attended schools in Dublin
1765–1768 and established himself
there as a miniaturist, 1768–1784. He
spent a period of eight years in London
before traveling to the United States in
1793 aboard the same ship as Gilbert
Stuart. In New York and Philadelphia
he maintained close ties with Stuart,
whose oil portraits he frequently cop-
ied in miniature. In late 1795 he
embarked for India where he died.
Dunlap described his accomplish-

ments: "Robertson's style was unique;
it was very clear and beautiful but was
not natural. . . . His style was very
singular and altogether artificial, all
ages and complexions were of the same
hue and yet there was a charm in his
coloring that pleased."[1]

1. Dunlap, *History*, II, 118, 98.

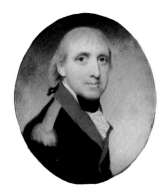

DANIEL STEVENS, 1748–1835
Watercolor on ivory, 46 × 40 mm
Gift of Mrs. Ridgely Hunt
34.6.1

A native of Charleston, Stevens was a
factor until the time of the Revolution.
He served first with the Charleston
Rangers, then in the artillery, finally
attaining the rank of Colonel. During
the siege of Charleston in 1780 he was
detained as a prisoner. Following the

war he held several positions including a seat in the House of Representatives, High Sheriff for the Charleston District, Senator from St. Luke's Parish (1785–1791) and for ten years was Supervisor of Revenue of the United States for the state. He served on the City Council and was elected Intendant 1819–1820.

Where Robertson painted Stevens' portrait is not known, as the artist is not thought to have made a trip to Charleston, although several South Carolinians were painted by him. Perhaps Stevens and his daughter were in Philadelphia, New York or Newport, RI, during the period 1793–1795.

Stevens is portrayed as an alert, even intense individual. The miniature, which originally may have been attached to a bracelet, is lively due to the cross-hatched brushstrokes and brilliant colors in the uniform.

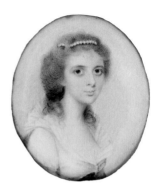

MARIA WILLARD STEVENS (MRS. THOMAS SOMERSALL), 1776–1806
Watercolor on ivory, 47 × 40 mm
Gift of Mrs. Ridgely Hunt
34.6.2

The daughter of Daniel Stevens, Maria Stevens was left motherless before she was one year old. She was raised by her father's third wife.

The miniature combines naturalism with subdued elegance to create a very pleasing portrait of a young woman. Textures are all-important, with dynamic contrasts between her soft hair, the glistening pearls and the starchy frills of her dress. As in the portrait of her father, the case could have been mounted on a bracelet.

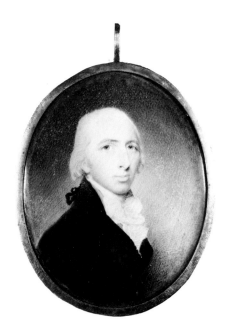

House. He married Margaret Izard in 1785.

The miniature resembles very closely a portrait by Gilbert Stuart (Albright-Knox Art Gallery, Buffalo) painted in New York in 1794. Robertson could have either made a version of the oil "in little" or availed himself of the same sittings while Manigault was in New York. The miniature is less stormy than Stuart's portrait, with more controlled lighting and more neatly coiffed hair.

Manigault's expression in the miniature verges on the supercilious, and the background is an unusual mustard-yellow.

GABRIEL MANIGAULT, 1758–1809
Watercolor on ivory, 63 × 53 mm
Purchase
51.4.1

A rice planter who studied law in London for a short time in 1777, Manigault became Charleston's most accomplished gentleman-amateur architect. He designed elegant houses in the Adamesque style for himself and his brother Joseph, the hall for the South Carolina Society, a building for a branch of the First Bank of the U.S. (now Charleston City Hall), and the Chapel of the Charleston Orphan

John Robinson
?– 1829

Robinson was an Englishman who settled in Philadelphia about 1817. He exhibited at the Pennsylvania Academy of Fine Arts 1816–1824.

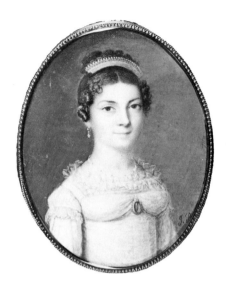

MRS. R. V. HURTEL (LEA ROSE VICTORIA JUDE)
Watercolor on ivory, 64 × 53 mm, 1822
Signed, lower right: JR
Purchase, Morawetz Fund
37.2.5

The locket is engraved on the verso, "R.V. Hurtel to LVR 1822," suggesting that the miniature was painted during the courtship of Hurtel and Lea Rose.

While Robinson's training was English, the miniature resembles continental—and specifically French—examples in its flat gray background and careful attention to dress. The facial features are sensitively drawn and the face is softly modelled to give a convincing sense of volume.

Nathaniel Rogers 1788–1844

After an apprenticeship with Joseph Wood, Rogers painted independently from 1811, mostly in New York. He became a member of the National Academy in 1826. Rogers is known for his ability to individualize his sitters and for the soft modelling of faces.

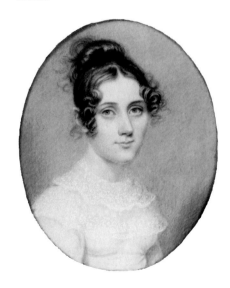

MARTHA JOHNSON
Watercolor on ivory, 55 × 70 mm
Gift of Thomas Waring in memory of
Celia Perronneau Mathewes Waring
82.11

No records on the life of Martha
Johnson have been located.

The somewhat wistful expression of
the sitter is quite typical of Rogers'
work, as is the slightly off-center
placement of the body.

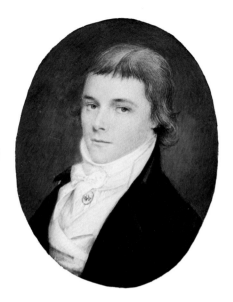

Samuel Smith, Jr.
1776–1812

A native of Massachusetts, Smith was
working in Charleston from 1801 until
his death. The locket of this miniature
contains a card bearing Smith's adver-
tisement which reads: "Miniature
painting/Samuel Smith jun,/leave
to inform his friends and the public
that/he still takes likenesses in mini-
ature/at his rooms, No. 27 Hasell
Street March 1, 1801." Smith also
served as principal teacher for the
South Carolina Society's school.

JOHN S. COGDELL, 1778–1847
Watercolor on ivory, 64 × 50 mm
Bequest of Emma Gilchrist
29.1.3

(For a biography of Cogdell see Fraser:
Cogdell.)

The portrait is a carefully painted
and sympathetic likeness, and makes
an interesting comparison to Fraser's
miniature of thirty years later. Smith's
confident handling of the medium may
derive from his training in London,
which in turn explains the resem-
blance his work bears to Malbone's.

Richard Morrell Staigg
1817–1881

Staigg, a native of England, came to the United States in 1831 and settled in Newport, RI. Encouraged to paint by Jane Stuart and Washington Allston, he was doing miniatures by 1838. He later painted in New York and was in Paris 1867–1869.

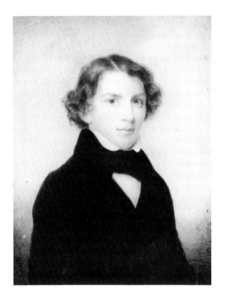

CHARLES MYRICK THURSTON,
1819–1878
Watercolor on ivory, 86 × 64 mm,
1840
Signed, on verso: Chas. M. Thurston,

Painted by Rich M. Staigg June 1840
Newport
Gift of Julia Lathers
35.2.1

Thurston was a native of Newport, RI, who became a merchant in New York. After retiring in 1856 he moved to New Rochelle, NY, where he was active in public service, as well as in historical societies and genealogical matters.

Staigg's style is straightforward, with an occasional tendency toward softly brushed areas, in this case the background.

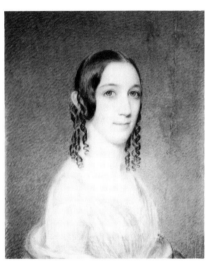

CAROLINE MARSH (MRS.
CHARLES THURSTON), 1823–?

Watercolor on ivory, 90 × 68 mm, 1841

Signed, on verso: Miss Caroline Marsh, painted by R. Staigg for Chas. Thurston, esq. Sep 2, 1841.

Gift of Julia Lathers

35.2.2

According to the inscription on the back, Caroline Marsh's portrait was done at the request of Charles Thurston, whom she later married. The portrait seems to have been painted during the young couple's courtship.

In contrast to the portrait of Charles painted eighteen months later, Caroline's face is finely and precisely painted, and the background has a distinctive stipple. Her dress, however, is only sketchily painted. These slight inconsistencies may be viewed as indications of a young artist. Staigg's youthfulness is also demonstrated by the repeated use of the same pose and placement for all three Thurston sitters.

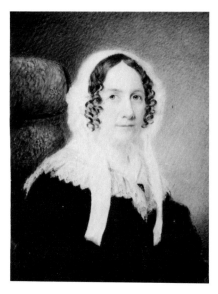

MRS. CHARLES THURSTON
(RACHEL HALL PITMAN),
1799–1887

Watercolor on ivory, 90 × 68 mm

Gift of Julia Lathers

35.2.3

Unlike the other two portraits by Staigg, this ivory is not inscribed. It probably dates from the same period, c. 1840. She is portrayed as a kindly matron, and is described in a family genealogy as ". . . bright in intellect, gentle and courteous in manner, kind and charitable to all."

All three miniatures of the Thurstons appear to have been painted in Newport, and there is no evidence that the artist or sitters ever came to Charleston.

Louisa C. Strobel (Mrs. Benjamin Martin)
1803–1883

Born in Liverpool, Strobel came to the U.S. first in 1812, but returned to France where she lived in Bordeaux 1815–1830. Her father, Daniel Strobel, Jr., was consul there.

Where Strobel obtained skill at painting miniatures is not known, but she may have trained with a French artist. Like many of the French artists who came to this country, such as Clorivière and Vallée, she preferred a solid, often steely-gray background. In her incredible attention to details, especially of costume, she resembles French artists. Her precision as well as her tendency to pose her sitters rigidly, foreshadow qualities found later in daguerreotypes. Upon her marriage in 1840 to Martin, a Presbyterian Minister, Strobel abandoned painting.

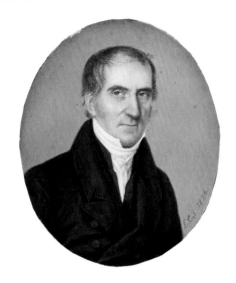

DANIEL STROBEL, JR.
Watercolor on ivory, 80 × 67 mm, 1826
Signed, at right: LCS 1826
Bequest of Daniel Strobel Martin
25.2.1

The father of the artist, Daniel Strobel was descended from a German family who were early settlers in Charleston. He served as consul at Bordeaux where his children were brought up. Later he was Deputy Collector of the Port of New York.

The realism and directness of this portrait is stark and is enhanced by the somber colors and yellow-green background.

MRS. DANIEL STROBEL, JR.
(ANNA CHURCH)
Watercolor on ivory, 80 × 67 mm
Signed, at left: LCS
Bequest of Daniel Strobel Martin
25.2.5

(Illustration on page 112)

Since Daniel Martin's bequest in 1925 this miniature has been identified as a portrait of Anna Strobel Bicknell, the artist's sister. As the sitter is clearly an older woman, it is much more plausible that the woman was in fact Louisa's mother. In addition, the size and format make an appropriate pair to Daniel Strobel, Jr.'s likeness.

Mrs. Strobel's elaborate headdress is probably of Bordeaux lace. The rigid pose, combined with precise detailing lead to an almost iconic image.

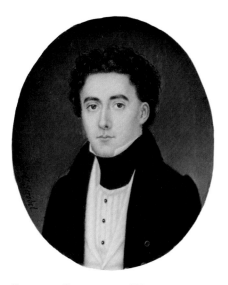

DANIEL STROBEL, III
Watercolor on ivory, 76 × 66 mm
Signed, at left: Louisa C. Strobel
Bequest of Daniel Strobel Martin
25.2.2

The brother of the artist, he was reared in Bordeaux. The facial features and clothing are finely detailed. His coat is a brilliant royal blue.

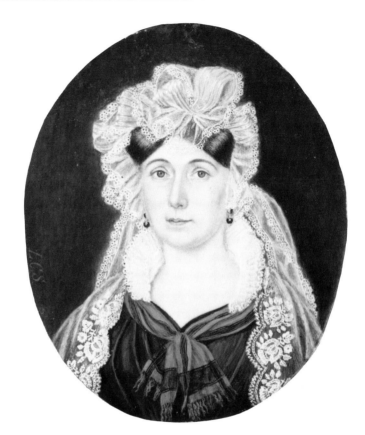

Louisa C. Strobel
Mrs. Daniel Strobel, Jr.

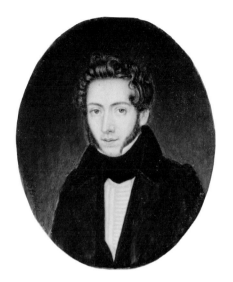

REVEREND GEORGE STROBEL
Watercolor on ivory, 69 × 58 mm
Signed at left: Louisa C. Strobel
Bequest of Daniel Strobel Martin
25.2.3

Reverend Strobel was the brother
of the artist. Upon his return from
France he became a Catholic priest.

As in the portraits of his brother
and father, here the technique is min-
utely detailed in the face and hair
while the coat and background are
more broadly brushed.

ANNA STROBEL (MRS.
BICKNELL)
Watercolor on ivory, 59 × 48 mm
Bequest of Daniel Strobel Martin
25.2.4

Anna was the sister of the artist
and married a member of the British
legation.

The artist has given her sister an
almost whimsical expression, which
contrasts the aloof moods of the other
sitters.

Lawrence Sully
1769 – 1804

The elder brother of Thomas Sully who would surpass him in longevity, popularity and painting skills, Lawrence Sully specialized in miniature portraiture. Working mostly out of Norfolk, VA, Sully's style was never fully established before his death at an early age.

SELF-PORTRAIT

Watercolor on ivory, 80 × 60 mm
Signed, at left: Louisa C. Strobel
Bequest of Daniel Strobel Martin
25.2.6

In her self-portrait Louisa continues her minute attention to detail, while simultaneously introducing a cloudy sky. The flowing veil, probably of Bordeaux lace, contrasts the rigid formality of her hairdo and dress.

ABRAHAM ALEXANDER,
1743 – 1816
Watercolor on ivory, 63 × 49 mm

Gift of John F. Alexander in memory
of Rosa Hays Alexander
71.14

A native of London, Alexander emi-
grated to Charleston c. 1760. He
became an active member of the
congregation of Kahal Kadosh Beth
Elohim and performed the duties of
lay rabbi 1764–1782. He held the
position of auditor at the U.S. Custom
House at Charleston 1802–1813 and
was a founder and first Secretary-
General of the Supreme Council of the
Scottish-Rite.

The miniature has consistently been
attributed to Sully. Certain passages in
it are awkward, including the painting
of the body.

Thomas Sully
1783–1872

Sully is best known for his elegant
and fashionable portraits which domi-
nated nineteenth-century American
art. As a boy Sully emigrated to
Charleston where he attended school
with Fraser, who offered him encour-
agement in the pursuit of art. Sully's
older brother, Lawrence, was a mini-
aturist, but Thomas himself rarely
painted miniatures.

M. S. THOMPSON
Watercolor on paper, 78 × 68 mm,
1811
Signed, lower right: TS; on verso:
M. S. Thompson, Islip, NY 1811
Gift of Mrs. Victor Morawetz
38.46.2

The portrait of Thompson should be
considered a quick sketch, probably
done by Sully as a personal tribute
to the sitter. It has the quick, spon-
taneous brushwork which is one of the
hallmarks of Sully's style. The inter-
twined monogram is also typical.

William Thomson
1771–1845

The son of a Scotch-American Loyalist, Thomson was taken to England from Savannah as a child. He is known to have exhibited at the Royal Academy from 1796–1843, and in 1829 he was elected to the Royal Scottish Academy.

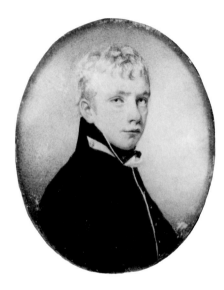

WILLIAM ROBERTSON
Watercolor on ivory, 80 × 65 mm, 1812
Signed on verso: Painted by William J. Thomson/ April 1812/ 41 Craven St/ Strand/ London

Bequest of Helen Robertson Blacklock
32.5.1

The miniature of Robertson is unusual in the profile view of the body with his head turned toward the viewer, and in its brilliant pink hues. The expression verges on being quizzical.

James Tooley, Jr.
1816–1844

Notwithstanding his father's wishes that he become a doctor, Tooley pursued a career as an artist. At eighteen he was in New York studying miniature portraiture, and after several restless years he settled in 1841 in Philadelphia. Tooley died of consumption at the age of twenty-eight, and his obituary stated: "The history of the native-born genius of Natchez is a melancholy one—the sad story of youthful promise nipped in the bud, or rudely torn away in the fragrant and beautiful flower."[1] His miniatures are typified by luminous and deep colors, the placement of sitters close to the picture plane, and by an intensity of expression.

1. *Mississippi Free Trader*, 28 August, 1844.

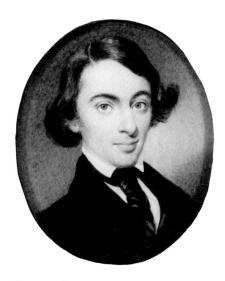 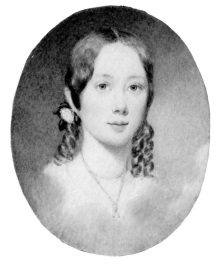

JULIUS PRINGLE
Watercolor on ivory, 61 × 51 mm,
1844
Signed, on verso: Tooley pinxt Jany
1844 Phila
Anonymous gift
36.12.2

The miniature may have been painted
in connection with Pringle's courtship
of Sarah Ashmead, whom he married
later in 1844. Pringle is a handsome,
even suave young man, according to
Tooley's portrait.

SARAH FORRESTER ASHMEAD
(MRS. JULIUS PRINGLE),
1824–1876
Watercolor on ivory, 69 × 54 mm
Gift of Victor Morawetz
36.7.7

A native of Lancaster, PA, Sarah mar-
ried Pringle in 1844. Their marriage
was marred by illness.

The portrait is a charming and
bright portrayal of a young woman,
and while probably painted at the
same time as Julius Pringle's they do
not seem to have been conceived of as
a pair. The effect of the clouds at the
bottom is somewhat dreamy and con-
trasts the wholesome realism of her
face and the somber tones of his
portrait.

Auguste Paul Trouche
1803(?) – 1846

Known almost exclusively as a painter of Low Country river scenes, Trouche was acclaimed in his own time as "rising to eminence in landscape." [1]

The basis for the identification as a self-portrait is family tradition, coupled with gold interlaced initials on the verso. In any event, the image is of a self-confident, and somewhat romantic young man about 1835.

1. *Courier*, 20 November, 1835

SELF-PORTRAIT
Watercolor on ivory, 53 × 45 mm
Gift of the Edwin Trouche Family in memory of Timothy Trouche
81.5

John Trumbull
1756 – 1843

The distinguished American historical and portrait painter, Trumbull did small portraits on wood, usually in preparation for his larger oil paintings. He was a native of Connecticut, and served in the Continental Army for two years before going to London to study under Benjamin West. During the period 1789 to 1794 he made numerous studies of Revolutionary War heroes and was in Charleston in 1791 with this purpose in mind. The Rutledge family was most hospitable, and in gratitude Trumbull painted small portraits of Mrs. Rutledge and her two children.

ELIZA RUTLEDGE (MRS. HENRY LAURENS), 1776–1842
Oil on mahogany, 82 × 70 mm
Gift of Mrs. Horace Holt
59.17

Colorplate XIII

Eliza, the daughter of John Rutledge, Revolutionary era patriot, was fifteen when Trumbull painted her portrait. It is a very sunny portrayal, dominated by the golden hues of her hair. The whole is spontaneously painted, and this, together with the simple pose, adds to the immediacy of the portrait.

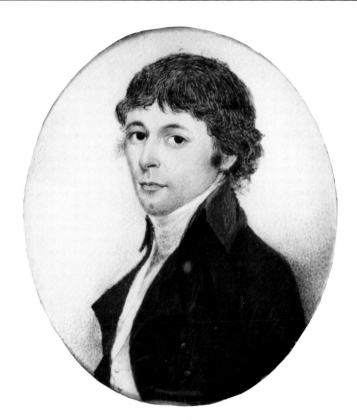

Auguste Paul Trouche
Self-Portrait

Jean François De La Vallée

active in the United States 1794–1815

Like other French emigrés Vallée had a scheme; his was to build a cotton mill in Virginia, and when it failed he resorted to miniature portraiture, traveling to Philadelphia (1794–1796); Charleston (1803, 1805, 1806); New Orleans (1810, 1815); and Boston (1826, 1828). His style is marked by a tendency to outline the silhouette, especially the top of the head of his sitters, often creating a collage-like effect against the slate-blue background. His works are frequently signed in pencil, "Vallée." Advertisements announcing his presence in Charleston cite "most correct likenesses," and indeed, his portraits are careful and individualized renderings.

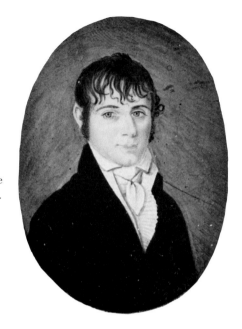

WILLIAM ALGERNON ALSTON,
c. 1781–1860
Watercolor on ivory, 58 × 47 mm
Gift of Colonel Alston Deas
65.29.1

Shown as a young man in his twenties, Alston acquired Rose Hill Plantation at about the same time the miniature was done. By his death at age seventy-nine his holdings included most of the important properties along the Waccamaw River. Vallée has painted the hair in a peculiar stringy fashion over the forehead and made the expression of the eyes very intense.

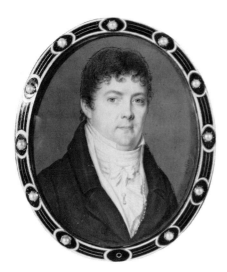

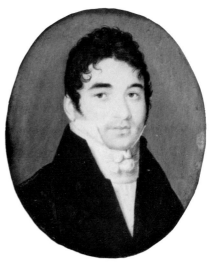

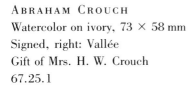

ABRAHAM CROUCH
Watercolor on ivory, 73 × 58 mm
Signed, right: Vallée
Gift of Mrs. H. W. Crouch
67.25.1

Crouch was a lawyer from Providence,
RI, who lived in Charleston. In 1806
he married Sophia Withers.

Vallée may have painted this por-
trait in 1805 or 1806, prior to Crouch's
wedding, and the miniature, which has
an especially rich and elaborate case
of gold, enamel and seed pearls may
have been given to the future Mrs.
Crouch. The portrait shows a solid-
looking and handsome man. The out-
line of the head against the opaque
background is one of the hallmarks of
Vallée's style.

JEAN PIERRE ESNARD (?)
Watercolor on ivory, 61 × 50 mm
Gift of Ione Barbot
37.27.1

Traditionally considered a portrait of
Esnard, who emigrated to Charleston
as a refugee from Santo Domingo, its
identity has been questioned. The
likeness resembles very closely a por-
trait of John Anthony Barbot (1785–
1855) a native of Bordeaux who mar-
ried Antoinette Esnard.

Vallée's portrayal is an unidealized
one which emphasizes the sitter's dark
coloring.

the back of a Windsor chair, allowing him to place Mrs. Fell along the central axis of the miniature.

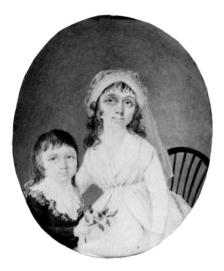

MRS. THOMAS FELL AND HER
SON WILLIAM, c. 1754–1819;
1789–1825
Watercolor on ivory, 73 × 62 mm
Gift of Mrs. Charles Lyon and Mrs.
Robert R. Rix
67.28

The rather unusual grouping of mother and son has aroused much speculation, due in part to the faded condition of the miniature, which makes the sitters look somewhat anemic, and to the honest depiction of the figures. One explanation suggests that the portrait is posthumous, but this is not borne out by the dates of the sitters.

Vallée has artfully balanced the composition through the inclusion of

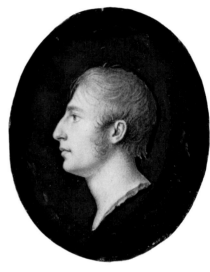

CHARLES FRASER, 1782–1860
Watercolor on ivory, 48 × 38 mm
Gift of Victor Morawetz
36.7.5

The association of the portrait with Fraser is traditional, but has been questioned. The profile, with its pronounced nose, sloping brow and full lips does resemble Fraser's *Self-Portrait* of 1823.

The way in which the profile is cut at the neckline, the absence of clothing and the monochromatic gray coloring

suggest that Vallée was attempting a cameo-like image. His usual unidealizing style and linear technique are apparent.

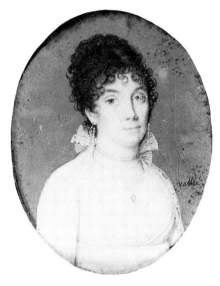

EDWARD CALHOUN
Watercolor on ivory, 48 × 38 mm
Gift of Mrs. Ellison Capers Johnson
63.34

A native of Abbeville, SC, Calhoun died at age eighteen. He was probably about three years old in the portrait.

Slightly disfigured due to flaking paint, Calhoun's portrait is a charming likeness of a pale-complexioned child. The now transparent collar may illustrate Vallée's skill, or be a result of changes in the paint's opacity.

MRS. WILLIAM ROBERTSON
Watercolor on ivory, 68 × 44 mm
Signed, lower right: Vallée
Bequest of Mrs. W. E. Simms
72.10.2

As in the portrait of Mrs. Shoolbred, Vallée has taken a great interest in the sitter's stylish details: her dress with its starchy collar, her pearl earrings and necklace and her abundant curls. The opaque rose background is unusual, and severe.

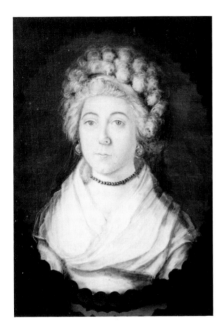

be powdered, a fashion that was out-moded by the time Vallée was in Charleston, and she wears a white kerchief as a shawl across her shoulders. The choker necklace and dangling earrings add decorative elements to an otherwise austere rendering.

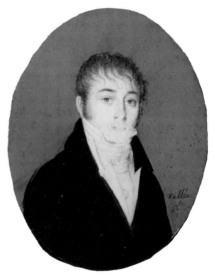

MRS. JAMES SHOOLBRED (MARY MIDDLETON), 1775–1860
Watercolor on ivory, 56 × 44 mm
Gift of B. Owen Geer
69.26

Mary Shoolbred was the maternal grandmother of James Shoolbred Gibbes, benefactor of the Carolina Art Association and the Gibbes Art Gallery. Her husband was the first British Consul at Charleston.

While the dark slate-colored background is very typical of Vallée's work, the costuming is especially intriguing: the abundant curls appear to

JOHN CHRISTOPHER SCHULZ, 17?–1833
Watercolor on ivory, 71 × 56 mm
Signed, lower right: Vallée pt
Gift of Mary Stanyarne Flud
56.9.1

As a child Schulz came to Carolina from Germany. He became a merchant

in Columbia, married, and then settled in Pendleton, SC, where he became a friend of Vice-President John C. Calhoun. It was at Calhoun's house, Fort Mill, that Schulz died. Letters written in 1829 to his eldest daughter while on an expedition into Georgia reveal him as a devoted and loving father and husband, and as having a sense of adventure and humor.

Vallée captured a slightly wistful expression on Schulz's face. The opaque background and the clear silhouette, as well as the delineation of the hair, are all hallmarks of Vallée's style.

Leila Waring
1876–1964

A distant relative of Malbone, Waring emerged as Charleston's chief miniature painter of the twentieth century. Her schooling in art consisted of private instruction, classes at the Gibbes Art Gallery school, and courses at the Art Students League in New York in 1902. She first exhibited as a professional miniaturist with the Pennsylvania Society of Miniature Painters in 1903. Subsequently, she regularly participated in the exhibitions at the Gibbes Art Gallery, culminating in

a retrospective of 103 works in 1956. Waring was also actively involved at the Gibbes Art Gallery as a researcher and organizer of the three miniature exhibitions of the 1930s.

While many of Waring's miniatures are of family members, she undertook commissions from Charlestonians, as well as from visitors to the city. Her account books record 210 miniatures. She discontinued her painting in 1948.

Waring's style is a pleasing synthesis of Malbone and Fraser with Impressionism. She preferred a light palette, visible brushwork and casual poses. She frequently worked from photographs.

KATHERINE BALL WARING (MRS. GEORGE WHIPPLE), 1887–1979
Watercolor on ivory, 63 × 53 mm, 1905
Signed, lower left: Leila Waring 1905
Gift of Mrs. George Whipple
67.31.3

(Illustration on page 126)

The sister of the artist, Katherine attended Goucher College and studied voice in New York. Her husband, a distinguished physician, was also a Nobel Prize winner.

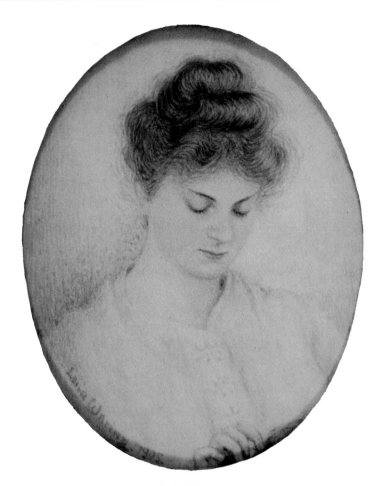

Leila Waring
Katherine Ball Waring

Katherine has been posed most unusually, with her eyes looking down at the fingers of her right hand. The soft brushwork and pale pink tones contribute to an intimate portrayal.

sixty years earlier when photography threatened the very existence of the miniature art form. As a result, it is very crisp with the light being more defined than usual.

SELF-PORTRAIT FROM A PHOTOGRAPH
Watercolor on ivory, 20 mm diameter, 1908
Signed, lower right: Leila Waring, 1908
Gift of Leila Waring
54.15.2

Waring has succeeded in an enchanting conception. She employed a photograph of herself as a child as the model for this likeness.

MRS. THOMAS GRANGE SIMONS, III (SERENA AIKEN)
Watercolor on ivory, 87 × 70 mm, 1906
Signed lower left: Leila Waring 1906
Gift of Albert Simons
72.8.2

In painting this portrait Waring used the assistance of a photograph, indicative of a complete turnaround from

CARDINAL JAMES GIBBONS,
1834–1921
Watercolor on ivory, 80 × 62 mm,
1917
Gift of Mrs. George Whipple
67.31.2

Cardinal Gibbons was born in Baltimore, but spent part of his childhood in Ireland and New Orleans. He entered St. Mary's Seminary and was ordained a priest in 1861. In 1868 he was made a Bishop, serving in North Carolina, Richmond (1872) and then Baltimore. He became Archbishop at age forty-two and was elevated to Cardinal on the twenty-fifth anniversary of his ordination (1886). He was an author, including *The Faith of Our Fathers* (1877) and served as an adviser to Presidents Harding, Cleveland, Roosevelt and Taft.

Waring painted the Cardinal's portrait on commission; it was to be sold for the benefit of the Serbian War Relief Fund. Although painted from life, the portrait lacks the immediacy and intimacy of her other portraits of family members and friends. The dark blue coloring and deep red of the Cardinal's robe also contribute to a somber mood. This miniature is a version of the original.

"AFTERNOON TEA" (DOROTHY WARING)
Watercolor, 76 × 60 mm, 1923
Signed, lower edge: Leila Waring
1923
Gift of Dorothy Waring
80.5.4

Colorplate XIV

Waring did not conceive of this work as a portrait but, in the vein of the Impressionists, has depicted a domestic scene of daily life. Stronger, richer colors have been employed here and, together with the activity of making tea, contribute to an interesting composition.

frontal half-length pose, allowing the viewer to focus on the sitter's face.

Madeline E. Shiff Wiltz

Like Charleston artist Leila Waring, Wiltz employed a technique very much indebted to Impressionism: light colors, painterly brushstrokes, and an intimate depiction.

ELIZA HUGER DUNKIN (MRS. PERCY KAMMERER)
Watercolor on ivory, 89 × 65 mm
Signed, along left: Leila Waring, 1923
Bequest of Mrs. Percy Kammerer
62.33.7

Eliza Dunkin shared an interest in miniature portraiture with her friend Leila Waring. She was a major benefactor of the miniature portrait collection at the Gibbes Art Gallery, with donations for the original display area in the 1930s and an endowment which provides for additions and changes to the installation.

Unlike many of Waring's other portraits, here the artist has used a

YOUNG WOMAN IN BLUE KIMONO
Watercolor on ivory, 112 × 82 mm, 1922

Signed, lower left: M Shiff 22
Gift of the artist
62.30

The inclusion of the blue kimono and the screen in the background are suggestive of the influence Japanese art and culture had on early twentieth-century art. The composition is almost a symphony in blue tones.

Caroline Withers

1830– 1906

Withers was active in Charleston before the Civil War.

ELIZABETH GIBBON (MRS. CARLYLE A. CURTIS), c. 1858–?
Watercolor on ivory, 43 × 36 mm, 1860
Signed, upper left: Caroline Withers 1860
Gift of Elizabeth Gibbon Curtis
28.1.2

The miniature represents a child of about two in a slightly awkward pose. The mid-century fascination with locket-encased miniatures may be seen as a reflection of the Victorian emphasis on sentiment.

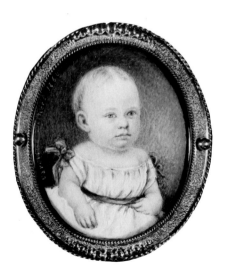

✎ Attributed Works ✎

C. Bak ?

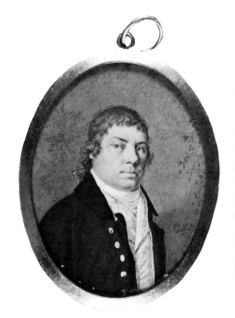

CHARLES PRINCE, c. 1767–1835
Watercolor on ivory, 63 × 50 mm,
1801
Signed, lower right: CBak 1801
Gift of Mrs. Francis O. Dukes in
memory of Major Francis Dukes,
Mrs. Dwight Simpson and Mrs. Alfred
de Beroft
65.20.2

An artist with the name Bak has not
been located, leading some to believe
that his name has been cut off by the
frame and might be considered Baker.
The style, in its opaque background,
linear handling, and attention to de-
tails of dress, resembles the work
of French emigré artists, especially
Vallée. The characterization is strong,
indicating an accomplished artist.

Attributed to
Esther Sage Benbridge

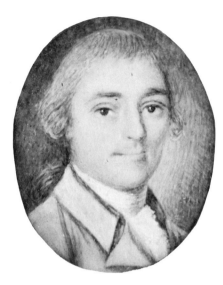

WILLIAM INGLESBY, 1750–1835
Watercolor on ivory, 33 × 27 mm
Gift of Charlotte Inglesby
68.11

A native of Peterborough, England, Inglesby emigrated to Charleston in 1785. He owned a plantation at Goose Creek and was active in the First Baptist Church where he served as Deacon.

For a long time attributed to Henry Benbridge, the portrait of Inglesby lacks the strong characterization and sharp contrast of light and dark so typical of Benbridge's work. The handling of the paint, likewise, is soft and the color is delicate. Although not previously suggested, the portrait could be the work of Hetty Benbridge.

Attributed to
Henry Benbridge

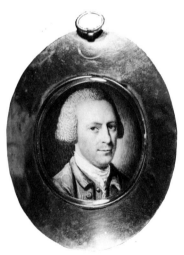

UNIDENTIFIED SITTER
Watercolor on ivory, 33 × 30 mm
Bequest of Mrs. Percy Kammerer
62.33.4

For a time the sitter was identified as John Huger (1744–1804), but this likeness does not look like Benbridge's miniature or the oil portrait of Huger by Edward Savage belonging to the City of Charleston.

The strong characterization and penetrating realism, as well as the coloring and placement of the head near the top of the ivory all resemble the work of Benbridge. The costume places the work in the 1790s.

Watercolor on ivory, 43 × 30 mm
Gift of Mrs. C. V. Steinhart in memory of Mrs. F. W. Ford
80.13.1

At one time identified as a portrait of Mrs. Elias Horry, Jr., it is now believed to represent Elizabeth Branford. Born in Bermuda, she married Branford in 1751. Jeremiah Theus painted an oil portrait of her as a young woman, which Fraser copied in 1845.

In its unidealized treatment of the sitter, the portrait relates to Benbridge's work. However, the blue and ashen coloring is somewhat unusual.

MRS. WILLIAM BRANFORD
(ELIZABETH SAVAGE)

Attributed to Henry Bounetheau

JOHN C. CALHOUN, 1782–1850
Watercolor on ivory, 111 × 90 mm
Purchase, Kammerer Fund
63.35

A native of Abbeville district, South
Carolina, Calhoun graduated from
Yale College in 1804, was admitted to
the Bar in 1807 and, after practicing
law for a few years, began a career
in politics. Serving first in the South
Carolina Legislature (1808), he pro-
ceeded to the U.S. House of Repre-
sentatives in 1810. In 1819 he was
named by President Monroe to be
Secretary of War, a post he held for
seven years. He was elected Vice-
President in 1824 with John Quincy
Adams and again in 1828 with An-
drew Jackson. He resigned, however,
in 1832 over the nullification contro-
versy, turning instead to the Senate
where he represented South Carolina
(1833–1843 and 1845–1850).

The miniature, which was at one
time attributed to Fraser, is a copy
after a miniature done by Washington
Blanchard in Washington in the early
1830s and now owned by the New
York Historical Society. The artist,
who may have been Bounetheau, ei-
ther worked directly from the original,
which at one time was in Charleston,
or from an engraving which appeared
in 1843.[1] It is a severe and pene-
trating likeness, made more so by the
elimination of a highlighted area be-
hind the figure. In addition, the face
and torso have been elongated.

1. Engraved by Archibald Dick for the *US
Magazine and Democratic Review*, 12, 1843, 93
and Robert Hunter, *Life of Calhoun*, 1843,
frontispiece.

A MEMBER OF THE BENNETT
FAMILY
Watercolor on ivory, 80 × 65 mm
Gift of Mrs. Victor Morawetz
38.46.3

For some time listed as an unknown
gentleman, the sitter is now presumed
to be a member of the Bennett family,
who were known patrons of art and
successful businessmen.

At one time attributed to Carlin,
the portrait has all the qualities asso-
ciated with Bounetheau's work: regular
stippling, simple posing and dark
colors.

JOHN HUME, 1762–1841
Watercolor on ivory, 117 × 90 mm
Gift of Mrs. Percy Kammerer in
memory of Aiken Simons
44.1.1

Hume, who had served as an aide to
General Francis Marion during the
Revolution, became the owner of
Hopsewee Plantation along the North
Santee River.

In 1822 Fraser recorded in his ac-
count book a portrait of Hume, and
again in 1841, a replica. It is gener-
ally believed that this is another copy
by Bounetheau, although it has also
been ascribed to Fraser and to Charles

Lanneau. In comparison to the Fraser original, the face and body have been given broader proportions while the stippling is more regular.

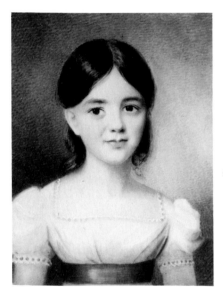

ANNE JANE NORTH, 1813–1876
Watercolor on ivory, 86 × 54 mm
Gift of Valeria and Edward Chisolm,
Mrs. John J. Prioleau, Mrs. Faust
Nicholson, Mrs. Charles Jervey and
Charles Jervey, Jr.
75.17.1

In 1835 Anne Jane North married
John Maxwell Chisolm, and following
his death she married William C. Bee
in 1858.

The young girl's portrait has been variously attributed, to both Fraser and Bounetheau. At this time the latter attribution seems the more plausible. The portrait is unusual in its size (a smaller rectangle than the norm) and in the centrality of the figure, which is awkwardly cut. The brushstrokes, which resemble Bounetheau's in some areas, are thickly painted.

Attributed to
John Carlin

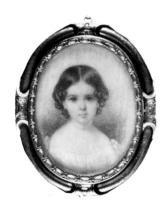

FANNIE MARIE COTTENET(?),
1871–1956
Watercolor on ivory, 40 × 33 mm
Bequest of Fannie Marie and Rawlins
Lowndes Cottenet
56.4.4

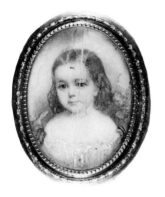

CHARLES LAIGHT COTTENET(?),
1861–1892 OR RAWLINS
LOWNDES COTTENET(?),
1871–1956
Watercolor on ivory, 41 × 33 mm
Bequest of Fannie Marie and Rawlins
Lowndes Cottenet
56.4.5

The exact identities of this young girl
and boy have never been established,
but the suggestion that they are the
Cottenet children seems valid in terms
of their dates, the artist and the prove-
nance. Although from a Charleston
family, they spent most of their child-
hood in New York where Carlin might
have painted them. The portrait of
the young girl, with pink bows on her
dress, appears to have been taken at
an older age than the young boy, who
has blue bows.

*Attributed to
Richard Cosway,
1742?–1821*

After attending several drawing
schools, including the Royal Academy,
Cosway won numerous awards, ex-
hibited widely and emerged as one of
the most fashionable miniaturists
of his day. In 1785 he was appointed
Principal Painter to the Prince Regent.
Cosway is known for his broad sweep-
ing strokes and for making his ivories
as luminous as possible. He preferred
a faraway gaze, which contributes to
the impression of elegant sophisti-
cation.

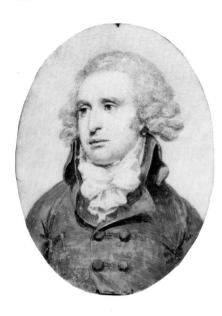

JOHN MATTHEWS, 1744–1802
Watercolor on ivory, 70 × 57 mm
Bequest of Mrs. Leger Mitchell
44.2.5

The sitter in this miniature has been
identified as Governor Matthews, na-
tive of South Carolina. He studied law
in London at the Middle Temple and
upon his return to Carolina was admit-
ted to the Bar in 1766. He was active
in the First and Second Provincial
Congresses, served as speaker of the
General Assembly in 1776 and of the
House of Representatives in 1778. He
represented South Carolina in the Con-
tinental Congress 1778–1782. In 1782
he was elected Governor and spent
most of his energy negotiating with the
British. From 1784–1797 he served as
chancellor and then judge of the court
of equity. Since Matthews never re-
turned to England, there is some doubt
about the sitter's correct identity.

Despite clear links with Cosway's
style, especially his late work, ques-
tions have been raised about the
attribution. The rather moody expres-
sion of the sitter and the dark coloring
of his jacket are more typical of Cos-
way's work after 1800. However, the
handling of the medium lacks Cosway's
usual crispness.

Attributed to Robert Field

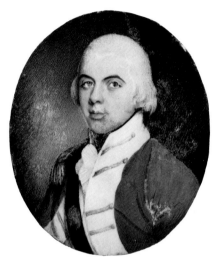

GEORGE BETHUNE DUNKIN
Watercolor on ivory, 70 × 60 mm
Gift of Mrs. Percy Kammerer
62.33.2

The sitter has been identified as
Dunkin, a member of a prominent
Boston family. However, he wears
the uniform appropriate to an English
Lieutenant in the mid-1790s.

Traditionally attributed to Field,
this ivory lacks the fresh sophistica-
tion usually associated with his mini-
atures and does not bear his usual
monogram. Nevertheless, the portrayal
is a handsome one. On a slip of paper

attached to the back is the following:
"Mr. J. W. . . . see Mr. . . . he will be at
little"

Attributed to Pierre Henri

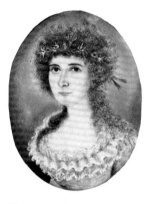

MRS. TOBIAS BOWLES
(SUSANNAH DRAYTON),
1777–1801
Watercolor on ivory, 60 × 50 mm
Gift of Dorothy Waring
80.5.2

(For a biography see Benbridge:
Susannah Drayton.)

The similarity to Mrs. Grimké's por-
trait by Henri is apparent, although
the detailing of the hair and flowers is
more precise, and the overall impact
is less imposing. The dark eyebrows
and delineation of the nose and mouth
relate well to Henri's other miniatures.

and a quizzical expression. The verso contains a pastoral scene in monochromatic browns of a stylishly dressed woman playing with a dog and birds.

MRS. JOHN CORDES (CATHERINE CORDES), 1724–1805
Watercolor on ivory, 43 × 32 mm, 1792
Gift of Victor Morawetz
36.7.21

Mrs. Cordes was the mother of Catherine Cordes Prioleau (Mrs. Samuel) who was painted by Fraser in 1820 as an older woman. According to an inscription on the gold rim of the locket the miniature was taken when Mrs. Cordes was sixty-eight years old.

In a manner not unlike the style of Henri it depicts an older woman in an unidealized way, with a double chin

MRS. JOHN CORDES (CATHERINE CORDES), 1724–1805
Watercolor on ivory, 43 × 31 mm, 1792
Gift of Catherine Porcher Langley
67.27

This appears to be another version of the previous entry. It bears the same inscription on the rim and a monochromatic scene on the verso, this

time of a single large tree with a country church in the background. Some details such as the arching of the eyebrows have been softened.

More crisply painted than many of Henri's miniatures, Elizabeth McPherson's portrait resembles the portrait of Mrs. Grimké in its emphasis on her dress and hairdo. At one time the miniature was incorrectly attributed to James Peale because a *P* was identified on the ivory. This monogram is no longer visible.

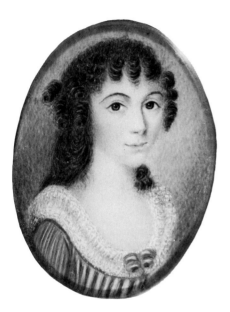

ELIZABETH MARY MCPHERSON
(MRS. JAMES REID PRINGLE),
1783–1843
Watercolor on ivory, 41 × 31 mm
Gift of Victor Morawetz
36.7.19

The locket is inscribed: "E. M. McPherson aged 9 years," suggesting a date of 1792 or 1793. She was the daughter of General John McPherson and sister to James. She married James Reid Pringle in 1807.

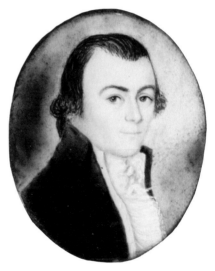

GOVERNOR PAUL HAMILTON,
1762–1818
Watercolor on ivory, 41 × 34 mm
Gift of Mrs. A. Baron Holmes, Mrs. Arthur Dixon, Mrs. W. Loring Lee, Florence Smyth
68.3.1

Although he was young during the Revolutionary War, Hamilton saw action under Generals deKalb, Gates, Marion and Greene. He served in the South Carolina House of Representatives in 1787 and 1788 and was a member of the conventions to adopt the federal and state constitutions. From 1800–1804 he successfully performed the duties of Comptroller General of South Carolina, followed by two years as Governor. Appointed by President Madison, he was Secretary of the Navy 1809–1812.

Although previously exhibited as painted by an unknown artist, Hamilton's portrait can probably be attributed to Henri. The face has the same sympathetic expression as signed examples, with the emphasis on the eyes and with a similar handling of paint. Only Hamilton's dark coloring and hair sets him apart from the others. A later engraved inscription on the verso of the locket: "Paul Hamilton /age 21/Governor of SC/1804 to 1806/Secretary of Navy/Madison Term" places the miniature at a date in the early 1780s, a possible contradiction of the attribution to Henri, who did not arrive in Charleston until 1790.

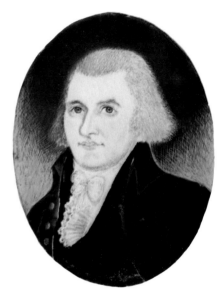

JOSEPH WATSON, c. 1769–1799
Watercolor on ivory, 48 × 37 mm
Gift of Mrs. Rose Raymond Goodbred
58.11.1

The locket bears the inscription: "Joseph Watson ob 3th January 1799 ae 30 years," which could have been added well after the portrait was painted.

Because the miniature exemplifies several of his characteristics, an attribution to Henri seems correct. The linear cross-hatching in the background is unusual, but the hairstyle, eyes, nose and mouth outlines relate well to the signed portraits by Henri.

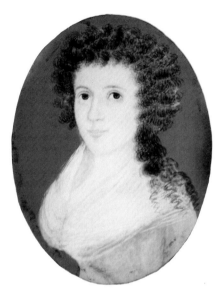

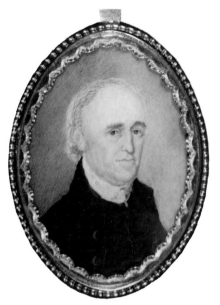

MARY WATSON
Watercolor on ivory, 46 × 33 mm
Gift of Mrs. Rose Raymond Goodbred
58.11.2

Mary Watson, whose maiden name
and dates are currently unknown, re-
married a Mr. Hunter following Joseph
Watson's death.

Like the portraits of Mary Grimké
and Susannah Drayton, the artist,
probably Henri, has placed the sitter
toward the top and emphasized the
hairdo. Mary Watson's expression of
reserved sadness is also similar to
Henri's other portraits.

COLONEL WILLIAM THOMSON,
1727–1796
Watercolor on ivory, 45 × 34 mm
Gift of Pauline S. Thomson
20.1.3

Known as "Old Danger," Thomson
was active in the Rangers during the
Cherokee War and against the British
during the attack on Sullivan's Island
in 1776. In 1778 he was commis-
sioned in the militia of Orangeburg
and in 1780 he was held prisoner
by the British. He also served in the
state senate for six terms.

Although more linear and less col-

orful than Henri's typical portraits, the portrayal has many of his curling mannerisms around the eyes and mouth.

portrait has been questioned. Her portrayal is fuller than his, with her body placed closer to the picture plane. Details of her bonnet and shawl are peripheral to her face which clearly dominates the oval.

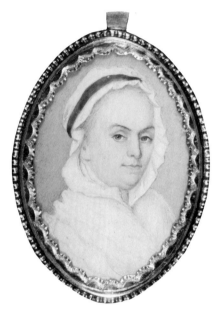

MRS. WILLIAM THOMSON (EUGENIA RUSSELL), 1734–1809
Watercolor on ivory, 45 × 34 mm
Gift of Pauline S. Thomson
20.1.4

Eugenia Russell married William Thomson in 1755 and she bore him fourteen children.

Mrs. Thomson's locket holds her husband's portrait on the reverse, and as in his portrait the authorship of her

Attributed to
Henry Inman

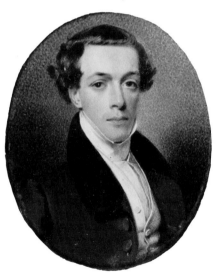

RAWLINS LOWNDES, 1801–?
Watercolor on ivory, 62 × 51 mm
Gift of James E. Leath, in memory of Clement March
39.1.1

Following his graduation in 1820 from West Point, Lowndes was stationed at Fort Moultrie; he served in the army until 1830. He had a plantation on the North Santee River and each spring returned to New York where in 1860 he resided permanently. He married Gertrude Livingston of New York in 1826.

This miniature has traditionally been attributed to Fraser, although stylistically it does not resemble Fraser's typical portraits. The format of the small locket was only occasionally used by Fraser, and the placement of the figure high upon the ivory and the extremely fine stippling and the gray-blue tones are without precedent in Fraser's work. Instead, the portrait may have been painted in New York where Lowndes is known to have spent part of each year. Lowndes' reticent expression and thin, narrow face have parallels in Inman's other portraits.

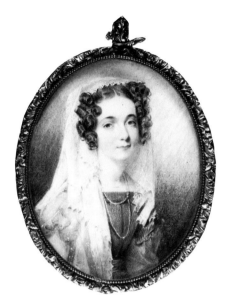

MRS. RAWLINS LOWNDES
(GERTRUDE LIVINGSTON)
Watercolor on ivory, 65 × 54 mm
Gift of James E. Leath in memory
of Clement March
39.1.2

The wife of Rawlins Lowndes, Gertrude was a native of New York.

The portrait was probably painted in New York in the mid-to late 1820s. Because of its fine detailing and aristocratic air it has been associated with Inman. However, he did few portraits of women, and he usually signed them. This miniature stands out because of its pink tonalities and exquisite detailing.

Attributed to
Joseph Jackson

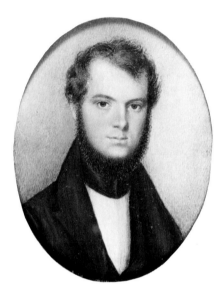

THOMAS CORBETT
Watercolor on ivory, 75 × 60 mm
Bequest of Margaret D. Mathews
38.40.1

While for some time this miniature
was unattributed, the association with
Jackson seems appropriate. The heavy
and dark pigments and the concern
for realism relate to the portraits of
the Greers by Jackson.

Attributed to
Jeremiah Meyer
1735–1789

A native of Germany, Meyer studied
in London and attained the position
of miniature portrait painter to the
Queen and painter in enamel to the
King in 1764. He was a founding
member of the Royal Academy where
he exhibited 1764–1783. Meyer's
miniatures are characterized by light
colors and a very precise technique.

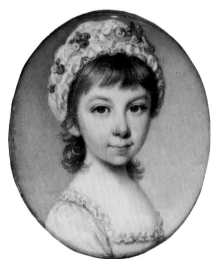

MARGARET IZARD (MRS.
GABRIEL MANIGAULT),
1768–1824

Watercolor on ivory, 40 × 34 mm
Purchase
67.22

Margaret Izard, daughter of Ralph
and Alice deLancey Izard attended
a convent school in France. In 1785
she married Gabriel Manigault,
Charleston's noted gentleman-amateur
architect.

Although it is possible that Margaret
Izard was in London c. 1774 for her
portrait to have been painted by Meyer
(her parents were there), the attribu-
tion has been questioned. Her frontal
pose and direct gaze are somewhat un-
usual, but the extraordinary detail and
pale colors relate well to Meyer's work.

*Attributed to
James Peale*

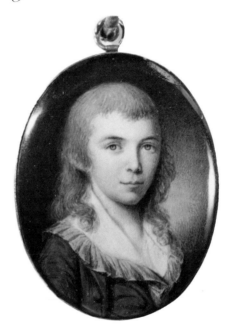

ARCHIBALD SCOTT, ?–1789
Watercolor on ivory, 48 × 38 mm
Purchase, Morawetz Fund
37.2.9

The young man has been identified as
Archibald Scott by a pencil notation
on a slip of paper inside the locket.
An individual of that name resided on
James Island.

Due to the small format and gray
tonalities, the portrait relates to
Peale's earliest period when the influ-
ence of Charles Willson Peale was the
strongest.

Attributed to
John Ramage

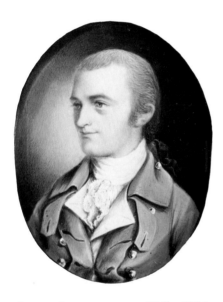

ADAM GILCHRIST, c. 1761–1816
Watercolor on ivory, 44 × 35 mm
Gift of Mrs. Robert Gilchrist
67.36

Gilchrist came to South Carolina about 1782 as a captain in the Pennsylvania section of the Continental Line. He became a successful merchant and served as President of the First United States Bank.

For some time the miniature was attributed to Henri, but it lacks most of his mannerisms and is unusually sophisticated. The three-quarter view and the brilliant, lavender jacket are most unusual. An attribution to Ramage seems most probable.

Attributed to
John Smart,
c. 1741–1811

Smart, who was both a precocious and prolific artist seems to have rivaled Cosway even from their student days. Smart was an active supporter of the Society of Artists 1762–1783, serving as its President in 1778, and disdained the Royal Academy in which Cosway figured. For ten years, 1785–1795, Smart painted miniatures in India, at Madras. Upon his return he exhibited at the Royal Academy 1797–1811.

Up until 1790, Smart's ivories were generally small and brilliantly colored and contrasted the elegant and translucent portraits by Cosway. He usually signed (J.S.) and dated his miniatures on the face.

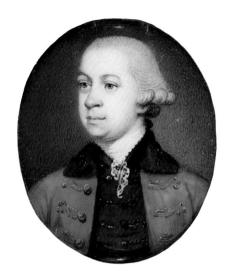

are more elegant and lighter in color. Stylistically the Gascoigne miniatures bear resemblances to Smart's work of the 1760s: the small round format, the placement of the figures toward the top, dark backgrounds, precise and unidealized rendering of the facial features, and a linear treatment under the lower eyelids. The deep colors of red and blue in the Admiral's uniform are also characteristic of Smart's portraits of men.

ADMIRAL JOHN GASCOIGNE (?)
Watercolor on ivory, 30 × 20 mm
Purchase
46.20.1

As a captain in the Royal Navy, Gascoigne commanded ships at Charles Town 1726–1738 to control the Spaniards and pirates. Following this duty he returned to England. Doubts have been raised about the correct identification of the sitter, as by the 1760s the Admiral must have been fairly advanced in age. The portrait may in fact be of Thomas Gadsden, Ann Gascoigne's first husband.

Because Gascoigne's miniature has no signature, the attribution to Smart has also been questioned. Richard Crosse (1742–1810) has been suggested, but in general his miniatures

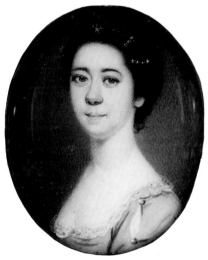

ANN GASCOIGNE (MRS. THOMAS GADSDEN), 1746–1808
Watercolor on ivory, 29 × 25 mm
Purchase
46.20.2

The daughter of Admiral Gascoigne, Ann married Thomas Gadsden in London in 1766 and came with him to Charles Town. Following his death she married Andrew Lord in 1770 and again, in 1796, William Greenwood. She is buried in St. Philip's Churchyard.

The coloring is more delicate than the Admiral's portrait, but the handling is similarly direct.

Attributed to Henry Spicer, 1743–1804

Spicer, who worked principally in enamel, exhibited at the Society of Artists 1765–1783 and at the Royal Academy 1774–1804. In 1774 he was appointed enamel painter to the Prince of Wales.

MRS. RALPH IZARD
(ALICE DE LANCEY), 1745–1832
Enamel mounted on gold snuff box,
50 × 43 mm, 1774
Signed, lower right: 1774 S
Gift of Mrs. Emma J. Gribben and Joseph Jenkins in memory of Josephine Manigault Jenkins
62.17

Colorplate XV

Alice de Lancey, a native of New York, married Ralph Izard in 1767 and had fourteen children. They lived abroad, 1771–1780, spending part of 1774 (the year of her portrait) in London and on a tour of the continent. While in Rome they sat for John Singleton Copley's famous portrait of them in front of the Colosseum and, together with Copley, the Izards were the first Americans to see the Greek temples at Paestum in Southern Italy. The attribution of this portrait to Spicer is based primarily on the enamel medium and the presence of a cursive S under the date, a device frequently employed by Spicer. The French enamelist Piat-Joseph Sauvage has also been suggested as the author, but little visual material is available to corroborate this idea.

The total impression of Mrs. Izard's portrait is one of refined elegance, intensified by the strong colors, the detailing of the pearls and the floral design on her dress.

Attributed to Benjamin Trott,
c. 1770–1843

Apparently from Boston, Trott led a peripatetic life which included stays in New York (1791, 1798, 1829–1833); Philadelphia (1793, 1798, 1806–1813); Charleston (1813, 1819); Newark, Boston (1833); and Baltimore (1839–1841). He died in Washington, D.C. where his obituary states: "His mind was vigorous, his genius undoubted, and his reputation equal to any other engaged in similar pursuits. His style of miniature coloring was rich and decisive, and bore a strong resemblance to the oil paintings of his friend Stuart."[1]

1. *National Intelligencer*, 28 November, 1843.

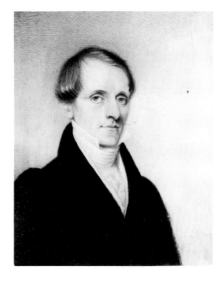

JOHN WARBURTON
Watercolor on ivory, 82 × 65 mm
Gift of Nancy Miles Durant in memory of Edward Warburton Durant
83.20

Originally a native of Rhode Island, Warburton also lived in Philadelphia where this miniature may have been painted.

The sharp characterization is typical of Trott's work as is the use of a very lightly painted background.

Works by Unidentified Artists

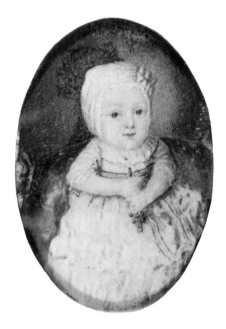

MARY BOWER(?), 1755–1758?
Watercolor on ivory, 55 × 40 mm
Gift of Mrs. William Robertson
45.11.1

The young girl has traditionally been identified as Mary Bower, with the dates 1755–1758. However, no information has come to light on this individual, while a Mary Bower who died in 1783 has been identified. The portrait may be a posthumous one, a fact born out by the association of mourning rings and lockets with miniatures. In addition, she clutches a rattle of gold bells with a coral handle; coral was a common symbol of warding off the evil eye, especially for children.

To add to the confusion, the style of the miniature is later than the eighteenth century and possibly even as late as 1825.

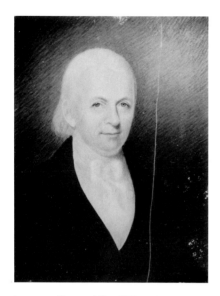

travel, loneliness and intrigue, which included being accused and acquitted of treason.

In its opaque and dense coloring the portrait is unusual, and suggests an artist unaccustomed to the subtleties and advantages of watercolor on ivory. The intense realism of some of the details, such as the wrinkles, and his peculiar expression are disturbing.

AARON BURR(?), 1756–1836
Watercolor on ivory, 88 × 62 mm
Anonymous gift
39.7.1

Some doubt has been raised about the correct identity of the portrait. A comparison with other portraits of Burr reveals similar hairstyle, arched eyebrows and high brow with receding hairline.

Burr had a varied and colorful career. A revolutionary war soldier, he practiced law and served as U.S. Senator and Vice President, 1804–1805. His famous duel with Alexander Hamilton occurred in 1804 and was followed by several years of

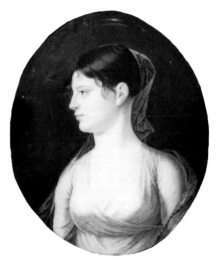

THEODOSIA BURR (MRS. JOSEPH ALSTON), 1783–1812,
after John Vanderlyn
Enamel (Sèvres porcelain?),
68 × 57 mm
Gift of Mrs. Richard Breckinridge and Colonel William L. Breckinridge
68.26

The daughter of Aaron Burr, as a child Theodosia studied both Latin and Greek as well as the sciences, history and literature, which was unusual for young women at the time. In 1801 she married Joseph Alston (later Governor of South Carolina) and aided her father during his trial. Her frail health was damaged further by her grief over the death of her only son. In December, 1812, she embarked on a boat for New York which never arrived, and she was presumed dead.

The enamel is a copy, which Aaron Burr seems to have commissioned while in Paris in 1811, of John Vanderlyn's 1801 portrait now at Yale University. The enamel follows the original oil, with a slight tendency to exaggerate and harshen certain features such as her nose, curls and the lines of her dress. The profile is striking and, in its enamel form, almost reminiscent of a classical cameo.

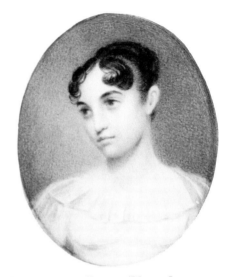

THEODOSIA BURR (MRS. JOSEPH ALSTON), 1783–1812
Watercolor on ivory, 72 × 62 mm
Gift of Mrs. Marion H. Brawley
84.2

The traditional identification of this pensive young woman is Theodosia Burr. The hair style is correct, and relates to other documented portraits of her. There is a soft, almost fuzzy quality of the brushstroke which works well with the romantic expression of the young woman.

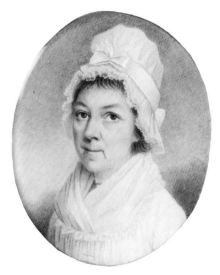

MRS. JOHN COLCOCK
(MELLESCENT JONES), 1744–1829
Watercolor on ivory, 62 × 54 mm
Gift of Dorothy W. Seago, Georgia
Seago Fisher and Mary Seago Brooke
82.1

Left widowed at age thirty-three, Mrs.
Jones conducted a school in her home
for young girls. She was painted by
Samuel F. B. Morse during his sojourn
(1817–1821) in Charleston, and in
both portraits is shown wearing a lace-
trimmed bonnet.

The characterization and modelling
of Mrs. Jones' miniature is strong, and
suggests an intelligent and self-reliant
woman. The background consists of a
careful cross-hatched pattern and is
an unusual pink-lavender.

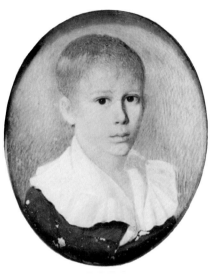

BOY OF THE COLLINS FAMILY
Watercolor on ivory, 62 × 52 mm
Purchase
45.9.1

Probably painted in the opening dec-
ade of the nineteenth century, this
miniature attractively conveys a young
red-haired boy with large brown eyes.
His somewhat sad expression is en-
livened to some extent by the warm
pink background and his dark, tur-
quoise coat.

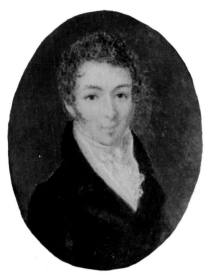

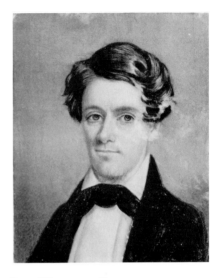

YOUNG MAN OF
COTTENET FAMILY
Watercolor on ivory, 61 × 50 mm
Bequest of Fannie Marie and Rawlins
Lowndes Cottenet
56.4.8

Because of the high collar and puffed
sleeves this portrait probably dates to
the mid-1820s. The opaque gray
background relates it to continental
miniatures.

DR. WILLIAM BONES
CRAWFORD, ?–1853
Watercolor on ivory, 52 × 63 mm
Gift of Mary Adams Hughes
81.7

Crawford was a physician from Winns-
boro, SC, who moved to Mobile, AL,
where he was married in 1842. Due to
poor health he went to Paris, and fi-
nally settled in Malaga, Spain, where
he died.

The portrait shows a pensive young
man c. 1840. It is painted on an
oddly shaped piece of ivory and some
of the details of the hair have been
scratched onto the surface.

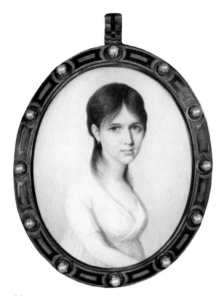

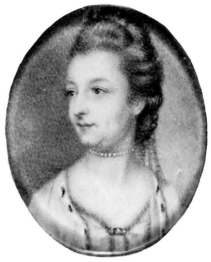

MRS. ABRAHAM CROUCH
(SOPHIA JANE WITHERS),
1788–1809
Watercolor on ivory, 70 × 57 mm
Gift of Mrs. H. W. Crouch
67.25.2

The young wife of Abraham Crouch,
Sophia died at age twenty-one and
is buried in St. Philip's churchyard.

The portrait was probably painted
c.1805 when Sophia was in her teens.
There is a youthful and wistful ex-
pression which is enhanced by the
pale colors. While the face is strongly
modelled, the hair has a linear quality
and the body is awkwardly propor-
tioned, suggesting perhaps an artist
who was beginning his career.

MRS. JOHN DEAS
(ELIZABETH ALLEN), 1742–1802,
after John Smart
Watercolor on ivory, 41 × 33 mm
Gift of Mrs. Nicholas Roosevelt
67.30.2

Elizabeth Allen married John Deas in
1759. This miniature appears to be a
late nineteenth-century copy of a 1773
portrait done by John Smart. The copy
is less precise and clear than the
original, tending toward softer
outlines.

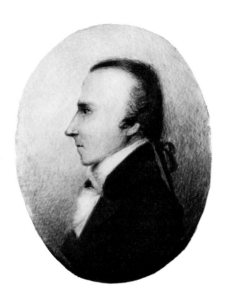

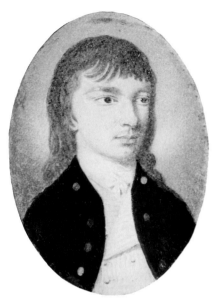

MR. FREEMAN
Watercolor on ivory, 73 × 58 mm
Gift of Victor Morawetz
36.7.13

Traditionally, Mr. Freeman has been identified as a Charleston merchant. He wears an early hairstyle (before 1800).

The profile of Freeman's nose appears exaggerated, and is only softened by the fuzzy brushstrokes.

JOHN AND THEODORE
GAILLARD, 1765–1826;
c. 1767–1829
Watercolor on ivory, 54 × 45 mm
Gift of Mrs. Francis Ford, Sr.
77.14.1

Both young men studied at the Middle Temple in London. John was elected to the State House of Representatives, 1794, and to the Senate, 1796–1804. Elected to the U.S. Senate, he served from 1805–1826. He frequently performed the duties of President *pro tempore*.

Theodore, the younger brother,

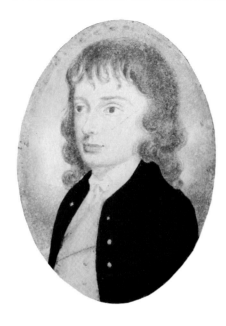

became a distinguished lawyer in Charleston. He served in the state legislature, and then he was Judge of the Court of Chancery 1808–1824, followed by an appointment as Judge of Court of General Session and Common Pleas.

According to tradition, this double locket, which is presently mounted as a swivel-pin, was painted in London while the boys were at school. The portraits are simple, suggesting an artist not working in the high-fashion circles of London. There is a tendency to flatten the tops of the heads and to exaggerate the eyes.

JAMES SHOOLBRED GIBBES, 1819–1888
Enamel on porcelain, 54 × 41 mm, 1866
Signed on verso: James S. Gibbes, 1866
Bequest of Mrs. Alexina I. C. Holmes 30.1.1

Colorplate XVI

A descendant of an old Charleston family, Gibbes was a successful merchant and stockholder in the South Carolina Railroad Company and the Gaslight Company. Through his bequest to the Carolina Art Association and the Mayor of Charleston, the Gibbes Memorial Art Gallery was erected.

An extraordinarily detailed likeness, it portrays Gibbes as a personable individual, somewhat in contrast to contemporary portraits which tend to be severe. The beautifully embellished locket suggests that it may have been designed for Mrs. Gibbes to wear.

MRS. JAMES SHOOLBRED GIBBES (MARY EVANS), ?–1888
Enamel on porcelain, 56 × 41 mm
Bequest of Mrs. Alexina I. C. Holmes 30.1.2

Colorplate XVI

The bright coloring of Mrs. Gibbes' portrait displays one of the advantages of the enamel medium, in contrast to the use of watercolors on ivory. In addition, because the colors have been baked into the porcelain substance, no protective glass is necessary.

Mrs. Gibbes, who appears as a Victorian matron, is shown wearing a miniature portrait brooch at her neck.

Charleston wharves. He was a charter member of the New England Society.

For some time attributed to Fraser, the portrait has some qualities in common with his style: the direct interpretation, and the stippling of the background. However, the small format and awkward juxtaposition of head and shoulders are not quite right. In addition, it is not listed in his account book, nor was it shown in the 1857 *Fraser Gallery*.

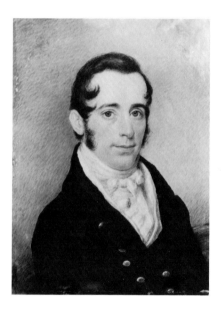

GEORGE GIBBON, 1793–1868
Watercolor on ivory, 80 × 63 mm
Gift of Mrs. Carlyle A. Curtis
28.1.1

Gibbon was a grain merchant, located along East Bay Street, near the

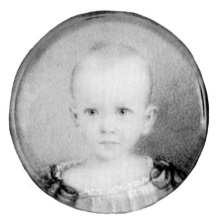

EMMA S. GILCHRIST, 1863–1929
Watercolor on ivory, 31 mm diameter
Bequest of Mrs. Leger Mitchell
44.2.1

The traditional identity of the sitter has been Emma Gilchrist at about age two. In sentiment it compares well to

the Carlin miniatures of the Laight and Cottenet children.

It is a careful, almost intense portrayal of a young child, which has been charmingly set in a gold locket.

with a sharp contrast created between her black dress and starchy white collar. The dark background is systematically and densely cross-hatched.

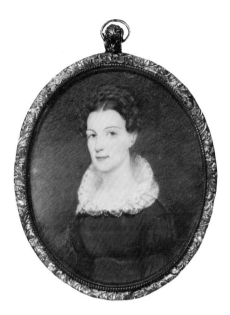

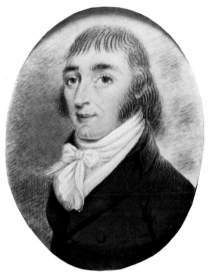

MRS. ROBERT BUDD GILCHRIST (MARY GILCHRIST), 1797–1867
Watercolor on ivory, 69 × 58 mm
Bequest of Mrs. Leger Mitchell
44.2.3

This sitter was the wife of Judge Gilchrist.

Probably painted during the 1820s, the portrait is attractively conceived,

DERRY GILLISON
Watercolor on ivory, 60 × 50 mm
Bequest of Annie T. Colcock
23.2.2

A native of Massachusetts, Gillison came to South Carolina and established a successful tanning business near Coosawhatchie, Jasper County.

Probably painted about 1800, Gillison's miniature is striking because of the linear treatment of hair, eyebrows

and eyelashes, its cool blue coloring, and the precise depiction of the features: long, pointed nose, small mouth and dimple in the chin.

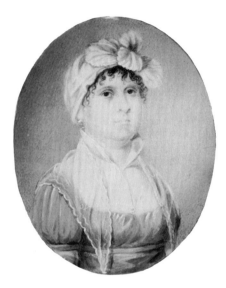

MRS. PAUL HAMILTON (MARY WILKINSON), 1763–1827
Watercolor on ivory, 64 × 52 mm
Gift of Mrs. A. Baron Holmes, III, Mrs. Dewar Gordon, Mrs. Arthur Dixson, Mrs. Loring Lee and Florence Smyth
68.3.2

Mary Wilkinson married Paul Hamilton in 1782. The verso bears an elaborate monogram, MH.

Erroneously exhibited in 1934 as a work by Fraser, the miniature has also been attributed to Rembrandt Peale. The artist was obviously highly skilled, as he has successfully given the illusion of a transparent drape across her bodice. In addition, there are some charming details, such as the black ringlets emerging under her bouffant cap.

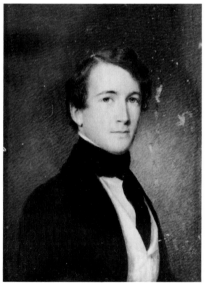

MAJOR THOMAS LYNCH HAMILTON
Watercolor on ivory, 82 × 64 mm
Gift of J. G. de Roulhac Hamilton
52.2.1

Hamilton was the son of South Caro-
lina Governor James Hamilton, Jr.

The miniature has for some time
been wrongly attributed to Fraser. It is
too dark and densely painted to be his
work. Nevertheless, the likeness is a
handsome and well painted one.

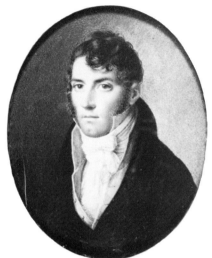

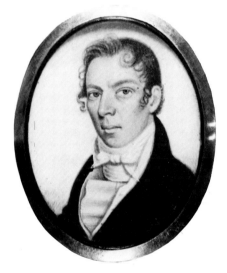

EDWARD HEXT
Watercolor on ivory, 59 × 46 mm
Gift of Anna Wells Rutledge
58.31

Certain slightly awkward passages,
such as the prominent nose and the
oddly foreshortened body, make this
portrait stand out.

NATHANIEL HEYWARD II
1790–1819
Watercolor on ivory, 92 × 75 mm
Bequest of Julius Heyward
24.4.7

Nathaniel was the second son of
Nathaniel Heyward I, and brother of
William Manigault Heyward.

Variously identified as the work of
either Fraser or Malbone, the mini-
ature of Heyward is both too heavy
and ponderous to be by either one of
them. It is possible that it was done
by an English or English-trained artist
c. 1810 or 1815. Despite the crisp sil-
houetting of the figure against the
background, there is a sophisticated
air about the portrait.

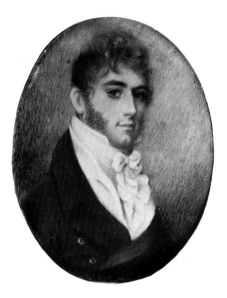

lighter with greater use of stippling. In 1849 Fraser made a copy of this portrait.

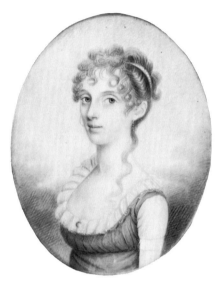

WILLIAM MANIGAULT HEYWARD, 1789–1820
Watercolor on ivory, 86 × 67 mm
Bequest of Mr. and Mrs. William Manigault Heyward
20.3.1

William was the elder brother of Nathaniel Heyward II.

A note on an old backing card states that the portrait was done in England when Heyward was about twenty-five, that is c. 1814. This statement corroborates the stylistic evidence, but the artist does not seem to be the same as the one who painted his brother's portrait. This portrait is

ELIZA HUGER(?), 1828–?
Watercolor on ivory, 82 × 62 mm
Bequest of Mrs. Percy Kammerer
62.33.5

Traditionally, the sitter is said to be Eliza Huger, who married Alfred Dunkin in 1851. However, the style of dress and painting places the portrait closer to 1800.

The pale coloring and delicate handling of paint make the portrait ele-

gantly understated. The long curl over her left shoulder helps to enliven the portrayal.

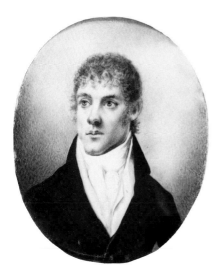

DR. WILLIAM LENNOX
KIRKLAND, 1797–1828
Watercolor on ivory, 72 × 60 mm
Gift of Mary Louise and Randolph Kirkland
83.6

Kirkland studied medicine in Philadelphia, and returning to Charleston c. 1822 he became active in real estate development. He died of yellow fever.

An extremely handsome miniature, it has been associated with Fraser by previous owners. More likely it was painted in Philadelphia during Kirkland's student days. The figure is placed high on the oval and is carefully drawn and modelled.

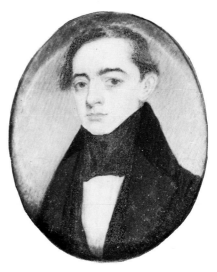

THOMAS LOWNDES(?), 1808–1838
Watercolor on ivory, 53 × 43 mm
Purchase
66.23

Probably painted c. 1835, the portrait is made quite severe by the wide cravat, high collar and wide lapels, which may have been exaggerated by the artist. The expression of the young man is serious.

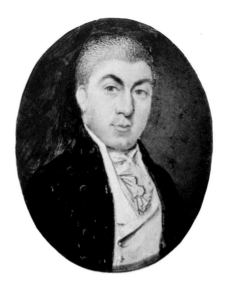

MR. PRINCE
Watercolor on ivory, 62 × 50 mm
Gift of Mrs. Francis O. Dukes in
memory of Major Francis O. Dukes,
Mrs. Dwight Simpson and Mrs. Alfred
de Beroff
65.20.3

The identification of the sitter is tradi-
tional, but nothing is presently known
about him.

Probably painted between 1800 and
1810, the portrait is distinctive for its
dark and heavily brushed background,
the speckled coloring of the hair and
the thick eyebrows. The verso con-
tains an attractive pastoral scene of a
woman, three sheep and a small dog
at a country gate.

MRS. PRINCE
Watercolor on ivory, 70 × 57 mm
Gift of Mrs. Francis O. Dukes in
memory of Major Francis O. Dukes,
Mrs. Dwight M. Simpson and Mrs.
Alfred de Beroff
65.20.5

The sitter in this miniature is pre-
sumed to be the wife of Mr. Prince.

Although severely damaged by
mold, the style of Mrs. Prince's por-
trait closely resembles Vallée in its
solid and dark background, attention
to details of dress and evidence of
graphite lines.

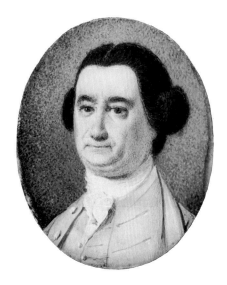

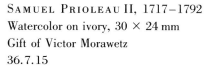

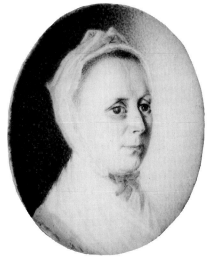

SAMUEL PRIOLEAU II, 1717–1792
Watercolor on ivory, 30 × 24 mm
Gift of Victor Morawetz
36.7.15

Prioleau was a substantial landowner, but lived primarily in Charleston. Under the siege of the British in 1780, he was banished on the *Torbay*.

The miniature closely resembles a bust-length oil portrait in the style of Jeremiah Theus and may in fact be a copy of it. The interpretation is emphatically realistic, with strong contrasts of light and shade.

MRS. SAMUEL PRIOLEAU
(PROVIDENCE HEXT), 1723–1775
Watercolor on ivory, 30 × 24 mm
Gift of Victor Morawetz
36.7.16

Providence married Prioleau in 1739. Her portrait is on the reverse of his and bears the following inscription on the bow of the locket: "P. Prioleau OBt FEBy 1775 AE 52."

Like her husband's portrait, Mrs. Prioleau's is unidealized and is based on an oil portrait. The miniatures seem to date from after her death in 1775.

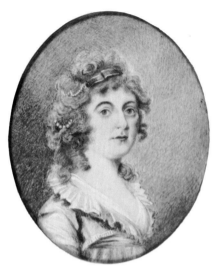

MRS. JOHN RAMSAY
(MARIA SMITH), 1770–?
Watercolor on ivory, 63 × 53 mm
Gift of Leila Waring
54.15.3

In this well-painted miniature, Mrs.
Ramsay is shown fashionably coiffed
and dressed in a manner popular
about 1795 or slightly thereafter. It is
carefully detailed and cross-hatched
in the background.

WILLIAM ROBERTSON
Watercolor on ivory, 86 × 73 mm
Bequest of Helen Robertson Blacklock
32.5.3

Robertson's miniature was painted
about 1807, and may be the work of
the English artist Charlotte Jones
(1768–1847). The hair and the back-
ground are finely stippled.

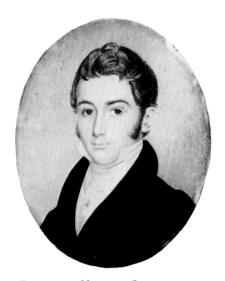

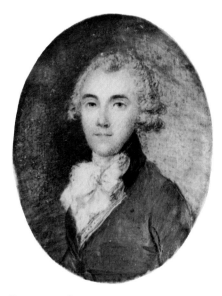

EPHRAIM MIKELL SEABROOK,
?–1846
Watercolor on ivory, 66 × 54 mm
Bequest of Mabel Hanahan
35.7.1

Seabrook entered the College of New Jersey (Princeton) as a sophomore in 1820 and graduated with the Class of 1823. A resident of Edisto Island, he wrote the *History of the Episcopal Church on Edisto Island*. He was a member of the Secession Convention.

According to tradition, the miniature was painted while Seabrook was at Princeton. It is a simply and carefully painted likeness.

FRANCIS SIMONS
Watercolor on ivory, 51 × 38 mm
Gift of Mrs. Percy Kammerer in memory of Aiken Simons
44.1.2

The costume of the sitter dates to the 1780s, but the handling of paint appears uncharacteristically fluid and too colorful for an American miniaturist working in that decade. The miniature could be a copy of an earlier work.

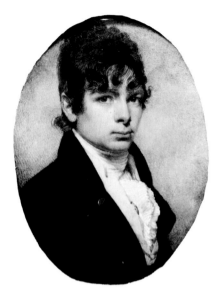

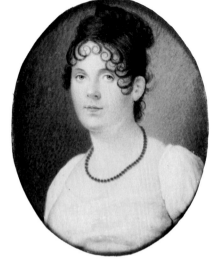

JOHN STOCK
Watercolor on ivory, 75 × 57 mm
Gift of Andrew Burnet and
William Francis Marion
82.14

Stock was a rice planter in the
Charleston area in the late 1700s and
early 1800s. His portrait was probably
painted between 1790 and 1800. At
one time attributed to Fraser, the min-
iature is almost too sophisticated in
technique for him, and in its synthesis
of honest realism and idealism is more
akin to Malbone's work.

MARTHA CAROLINE SWINTON,
1785–1847
Watercolor on ivory, 76 × 63 mm
Gift of Marie Taveau
80.3

Martha Swinton was married to John
Ball, Sr. and, following his death, she
married A. T. Taveau. She had fifteen
children.

An attractive likeness, it was prob-
ably painted about 1815. The artist
has lavished a lot of attention on her
numerous curls. The coral necklace
helps to soften and give dimension to
the portrait.

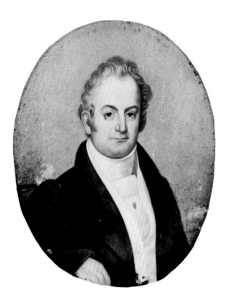

WILLIAM SABB THOMSON,
1785–1841
Watercolor on ivory, 125 × 100 mm
Gift of Dorothy Waring
80.5.1

Thomson owned a plantation, called
Richmond Hill, in Orangeburg
County.

In his portrait, probably painted in
the 1830s, Thomson appears as a suc-
cessful middle-aged man. In style the
miniature resembles the work of
Bounetheau: somewhat dry and tight
in technique. The addition of the sit-
ter's right hand adds an odd note of
illusionism.

YOUNG MAN OF
THE TIDYMAN FAMILY (?)
Watercolor on ivory, 38 × 29 mm
Bequest of Mrs. Mary Porcher
Gadsden Sinkler
55.14.1

The identity of this young man has not
been established, although tradition
associates the portrait with the Tidy-
man family.

The miniature has been incorrectly
attributed to Walter Robertson, who
painted portraits of Mrs. Philip
Tidyman and Hester Rose Tidyman.
While similar in size and technique,
it is too rugged and rumpled a por-
trayal for Robertson, who is usually
refined and detached.

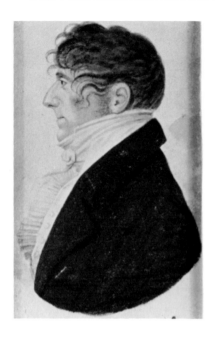

and windswept hair, it resembles the numerous profiles recorded by Charles B. J. F. de Saint-Memin.

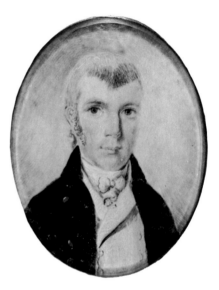

MR. TWAITS (?), ?–1814
Watercolor on paper, 86 × 59 mm
Bequest of Mrs. Leger Mitchell
44.2.2

Traditionally, it was believed that this is a portrait of the noted comedian Mr. Twaits, who died in New York. Another possible identification is William Twaits, who was acting manager of the Charleston Theater 1810–1812.

At one time the profile was attributed to Fraser, although there are few examples close to it in Fraser's oeuvre. Because of its sharp profile

JOHN WARREN, 1768–1829
Watercolor on ivory, 62 × 50 mm
Gift of Mrs. John Robson
50.5.1

Warren held substantial property in St. Thomas Parish called Warrens Island.

The portrait was probably painted about 1790 and exemplifies a sparse style in which the brushstrokes are vividly apparent.

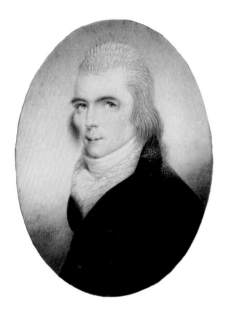

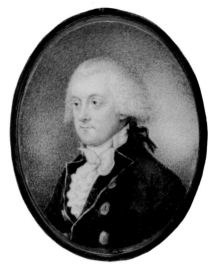

RICHARD YEADON, 1773–1841
Watercolor on ivory, 62 × 50 mm
Gift of Jeanne Gadsden
51.2.1

Yeadon was a Charleston silversmith.
 The portrait, probably painted between 1790–1795, is striking in several respects, including the intense gaze, powdered hair, full eyelashes and colorful waistcoat. In addition, the lighting is dramatic.

UNIDENTIFIED GENTLEMAN
Watercolor on ivory, 70 × 54 mm
Gift of Mrs. Francis O. Dukes in memory of Major Francis O. Dukes, Mrs. Dwight M. Simpson and Mrs. Alfred A. de Beroff
65.20.4

A distinguished-looking man, the sitter wears a hairstyle and clothes popular in the 1790s. The style of the miniature is meticulously realistic, showing the sitter's wrinkles, and the background is carefully stippled.

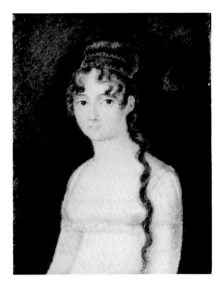

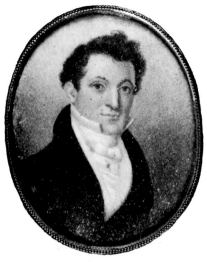

YOUNG WOMAN IN WHITE
Watercolor on ivory, 100 × 80 mm
Gift of Mrs. R. B. Gilchrist in memory
of Georgette Relph Wilson and
Mrs. William Edward Holmes
68.31.4

The miniature probably dates to the
opening years of the nineteenth cen-
tury when white, Empire style dresses
were popular. The technique is some-
what heavy-handed.

UNIDENTIFIED GENTLEMAN
Watercolor on ivory, 50 × 44 mm
Bequest of Mrs. Percy Kammerer
68.31.2

Certain mannerisms such as the
strongly arched nose and sweepingly
brushed hair make the miniature
striking. The coloring is somber.

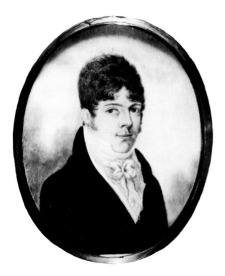

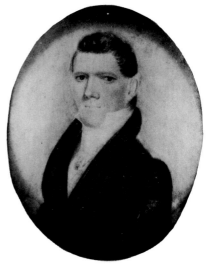

UNIDENTIFIED MAN
Watercolor on ivory, 69 × 57 mm
Gift of Victor Morawetz
37.2.11

The portrait was probably painted
about 1805. It has a cloudy-white
background, and some of the flesh
tones have a brown cast to them.

UNIDENTIFIED MAN
Watercolor on ivory, 76 × 65 mm
Bequest of Eugenia Estill
40.27.6

This portrait is a somewhat awkward
portrayal in which the artist has styl-
ized the lines of the sitter's jacket.
His asymmetrical gaze and pose with
his left arm over the chair back add to
a peculiar likeness.

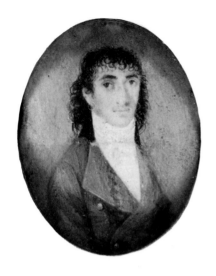

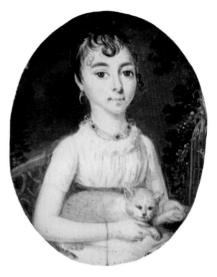

UNIDENTIFIED MAN WITH
EARRINGS
Watercolor on ivory, 57 × 46 mm
Purchase
46.10.1

The immediate impression here is of a
foreign, possibly Spanish, sitter, be-
cause of his long, dark, curly hair and
earrings. The artist's style is similar to
Vallée's, but the costume dates it
closer to 1815.

YOUNG GIRL WITH CAT
Watercolor on ivory, 56 × 45 mm
Gift of Mrs. Percy Kammerer
62.33.6

The placement of the sitter close to
the upper perimeter of the ivory and
her disproportionately large head sug-
gest the work of an amateur artist. In
addition, the artist has included al-
most too much visual information,
such as the landscape background,
the cat and the jewlery.

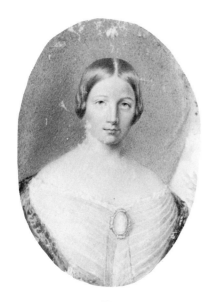

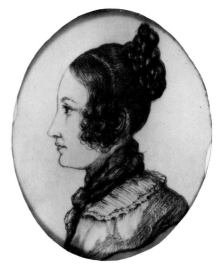

UNIDENTIFIED WOMAN
Watercolor on ivory, 76 × 57 mm
Bequest of Helen Robertson Blacklock
32.5.4

A neatly controlled miniature, it appears severe because of the symmetry of her hair and dress. The soft pink hues of her dress are complemented by the pale green of the background.

UNIDENTIFIED YOUNG WOMAN
IN PROFILE
Graphite on ivory, 65 × 55 mm
Bequest of Fannie Marie and Rawlins Lowndes Cottenet
56.4.9

The medium used here is called *plumbago*, that is, a drawing in graphite or lead. Its use on ivory is unusual. The profile is severe, although graceful. Her highly piled hair neatly balances her features.

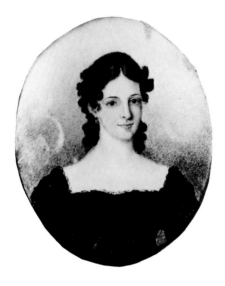

UNIDENTIFIED YOUNG WOMAN
Watercolor on ivory, 78 × 46 mm
Gift of Mrs. R. B. Gilchrist
68.31.3

The simplest of all poses—frontal—
has been used in this portrait which
may have been done by an amateur
artist. She has a sweet, smiling ex-
pression which is aided by the soft
curls around her face.

✑ Bibliography ✑

Includes general reference books most frequently used and the most significant monographs and articles on individual artists.

Bilodeau, Francis and Mrs. Thomas J. Tobias, *Art in South Carolina 1670–1970*, Charleston, SC, 1970.

Bolton, Theodore, *Early American Portrait Painters in Miniature*, New York, NY, 1921.

———, "Henry Inman, An Account of His Life and Work," *Art Quarterly*, Autumn, 1940, 353–375; supplement, 401–418.

Croce, George and David Wallace, *The New York Historical Society's Dictionary of Artists in America*, New Haven, CT, 1957.

Dunlap, William, *A History of the Rise and Progress of the Arts of Design in the United States*, Boston, MA, 1918, 3 volumes.

Jaffe, Irma B., *John Trumbull: Patriot-Artist of the American Revolution*, Boston, MA, 1975.

Long, Basil S., *British Miniatures*, London, 1929.

Morgan, John Hill, *A Sketch of the Life of John Ramage, Miniature Painter*, New York, NY, 1930.

Murdoch, John, Jim Murrell, Patrick J. Noon, and Roy Strong, *The English Miniature*, New Haven, CT, 1981.

O'Brien, Donough, *Miniatures in the XVIIIth and XIXth Centuries*, New York, NY, 1951.

Riordan, Bernard and Alice Hoskins, *Robert Field 1769–1819*, Halifax, Nova Scotia, 1978.

Rutledge, Anna Wells, *Artists in the Life of Charleston: Through Colony and State From Restoration to Reconstruction*, Philadelphia, PA, 1949.

———, "Henry Bounetheau (1797–1877) Charleston, S.C. Miniaturist," *American Collector*, July, 1948, 12–15, 23.

———, "A French Priest, Painter and Architect in the United States: Joseph-Pierre Picot de Limoelan de Clorivière," *Gazette des Beaux Arts*, March, 1948, 159–76.

————, "Henry Benbridge (1743–1812?) American Portrait Painter," *American Collector*, October, 1948, 8–10, 23; November, 1948, 9–11, 23.

Schidlof, Leo R., *The Miniature in Europe in the 16th, 17th, 18th and 19th Centuries*, Graz, Switzerland, 1964.

Severens, Martha R. and Charles L. Wyrick, Jr., *Charles Fraser of Charleston: Essays on the Man, His Art and His Times*, Charleston, SC, 1983.

Smith, Alice Ravenel Huger, "Charles Fraser, The Friend and Contemporary of Malbone," *Art in America*, June, 1915, 174–183.

————, "The Miniatures of Charles Fraser," *American Magazine of Art*, April, 1934, 198–202.

————, and D. E. H. Smith, *Charles Fraser*, New York, NY, 1924.

Stewart, Robert G., *Henry Benbridge (1743–1812): American Portrait Painter*, Washington, DC, 1971.

Tolman, Ruel Pardee, *The Life and Works of Edward Greene Malbone 1777–1807*, New York, NY, 1958.

————, "Attributing Miniatures," *Antiques*, November, 1928, 413–416; December, 1928, 523–526.

————, "The Technique of Charles Fraser, Miniaturist," *Antiques*, January, 1935, 19–22; February, 1935, 60–62.

Wehle, Harry B., and Theodore Bolton, *American Miniatures 1730–1860*, New York, NY, 1927.

Wharton, Anne Hollingsworth, *Heirlooms in Miniatures*, Philadelphia, PA, 1898.

EXHIBITIONS RELATING TO MINIATURES AT THE GIBBES ART GALLERY

Carolina Art Association Exhibition of Paintings, 1905.

Annual Exhibition of the Carolina Art Association, 1912.

Charles Fraser, 1934.

Exhibition of Miniatures From Charleston and Its Vicinity Painted Before the Year 1860, 1935.

An Exhibition of Miniatures Owned in South Carolina and Miniatures of South Carolinians Owned Elsewhere Painted Before the Year 1860, 1936.

Charles Fraser of Charleston, 1983.

For sitters' biographies see: *South Carolina Historical Magazine*

Index of Proper Names

CREDITS

Terry Richardson, Archival Lab

Arthur Vitols, Helga Photo Studio

Linda and Tom Starland, IF Labs

Set in Mergenthaler Bodoni Book and Snell Roundhand

by G & S Typesetters, Austin, Texas

Production by Sandra Strother Hudson

and Kathi L. Dailey, Athens, Georgia

Printed by Mercantile Printing Company,

Worcester, Massachusetts